MFA

HIGHLIGHTS arts of south asia

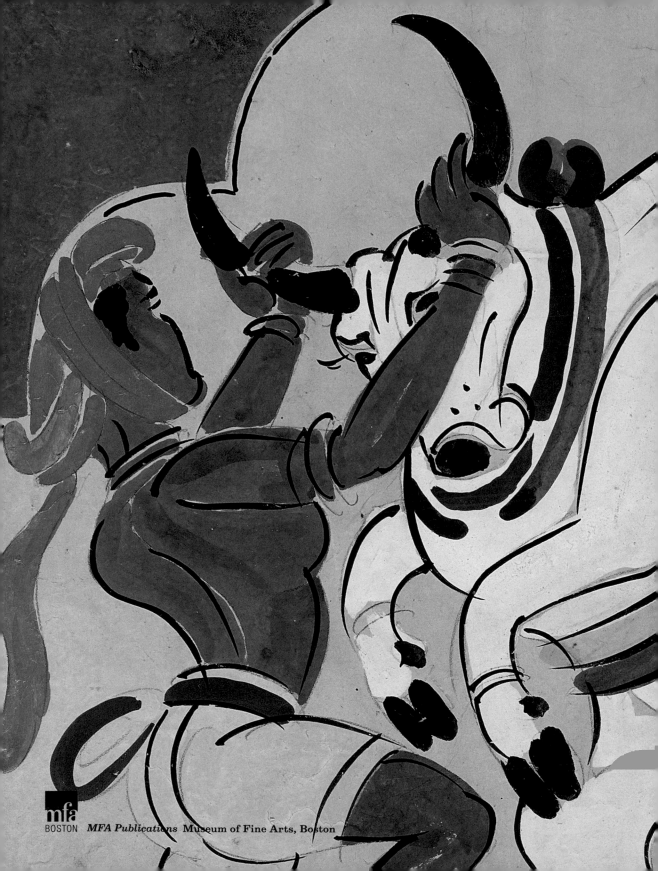

mfa
BOSTON *MFA Publications* Museum of Fine Arts, Boston

MFA

HIGHLIGHTS arts of south asia

Laura Weinstein

MFA PUBLICATIONS
Museum of Fine Arts, Boston
465 Huntington Avenue
Boston, Massachusetts 02115
www.mfa.org/publications

Support for this publication was provided by
Monica Chandra and Nitin Nohria, Nalini and
Raj Sharma, and Steve and Barbara Gaskin

The Museum of Fine Arts, Boston, is a nonprofit insti-
tution devoted to the promotion and appreciation of
the creative arts. The Museum endeavors to respect
the copyrights of all authors and creators in a manner
consistent with its nonprofit educational mission. If you
feel any material has been included in this publication
improperly, please contact the Department of Rights
and Licensing at 617 267 9300, or by mail at the above
address.

While the objects in this publication necessarily rep-
resent only a small portion of the MFA's holdings, the
Museum is proud to be a leader within the American
museum community in sharing the objects in its col-
lection via its website. Currently, information about
approximately 400,000 objects is available to the public
worldwide. To learn more about the MFA's collections,
including provenance, publication, and exhibition his-
tory, kindly visit www.mfa.org/collections.

For a complete listing of MFA publications, please con-
tact the publisher at the above address, or call 617 369
3438.

All illustrations in this book were photographed by the
Imaging Studios, Museum of Fine Arts, Boston, except
where otherwise noted.

Edited by Jodi Simpson
Production editing by Diana Sibbald
Proofread by Dianne Woo
Typeset by Fran Presti-Fazio
Design and production by Christopher DiPietro and
Terry McAweeney
Series design by Lucinda Hitchcock
Production assistance by Jessica Altholz Eber
and Anne Levine
Printed and bound at Verona Libri, Verona, Italy

Distributed in the United States of America and
Canada by
ARTBOOK | D.A.P.
75 Broad Street, Suite 630
New York, New York 10004
www.artbook.com

Distributed outside the United States of America and
Canada by
Thames & Hudson, Ltd.
181A High Holborn
London WC1V 7QX
www.thamesandhudson.com

FIRST EDITION
Printed and bound in Italy
This book was printed on acid-free paper.

Contents

Director's Foreword

The Museum of Fine Arts, Boston, is one hundred and fifty years old this year. The collections of the MFA, collaboratively built over these fifteen decades by curators, collectors, and many art supporters, bear witness to our ambitions to tell the global story of civilization through art. The Museum's embrace of global cultures reached the arts of South Asia as early as 1914, with the acquisition of a collection of Mughal paintings. In 1917, with the arrival of the Ross-Coomaraswamy collection, the MFA became the first museum in the United States to establish a collection of Indian art. That same year, the MFA also became the first U.S. museum to hire a curator, Ananda K. Coomaraswamy, dedicated to the care of a collection of Indian art. In 2010, anonymous funders honored Coomaraswamy's legacy by endowing the Ananda Coomaraswamy Curator of South Asian and Islamic Art, ensuring the continuity of the MFA's leading position in this field.

Forged in the crucible of Indian anticolonial nationalism, the collection was built to be a visual and material argument for the depth and importance of South Asia's cultural traditions. The beauty, subtlety, and sophistication of the objects ensure that this argument is no less compelling today. And yet, seen in a contemporary light—and with the addition of South Asian objects from the nineteenth through the twenty-first centuries—the collection challenges the very assumptions about religion, identity, and belonging with which it was formed. By sharing the artworks in this volume, we hope to convey our deep respect for South Asia's artistic and cultural traditions and to spark readers' curiosity about the origins, histories, and meanings of all cultures in the present day.

Matthew Teitelbaum
Ann and Graham Gund Director
Museum of Fine Arts, Boston

Acknowledgments

Two men created the Museum of Fine Arts, Boston's South Asian art collection, the first of its kind in the United States: Denman Waldo Ross and Ananda K. Coomaraswamy. In 1917, these pioneering scholars conspired to bring Coomaraswamy's exceptional collection of Indian paintings to the Museum, and to install Coomaraswamy himself as curator. In the decades that followed, Ross donated a series of spectacular works of Indian art to the MFA, expanding the collection significantly. At the same time, Coomaraswamy's groundbreaking research and writings spread knowledge about the art of the Indian subcontinent across the United States and beyond. To study and write about the objects Ross and Coomaraswamy assembled in Boston is, therefore, to pay homage to those who forged a physical, institutional, and conceptual space for Indian art and culture in America where there had previously been none. This volume is written in that spirit.

Many generous and committed collectors followed Ross and Coomaraswamy, to whom I am also deeply indebted. They include individuals who made their mark in the first half of the twentieth century, such as Mrs. Frederick L. Ames, William Sturgis Bigelow, Elizabeth Day McCormick, Edward Royall Tyler, Mrs. Frank Clark, and Mrs. John D. Rockefeller Jr. Following them are those who donated important works of art in more recent decades, including James Deering Danielson, Richard Milhender, Mark Baron and Elise Boisanté, Peter and Agnes Serenyi, and above all John Goelet, whose gifts alone make up nearly a fifth of the art featured in this volume. For his friendship and mentorship during and even long before the writing of this book, thanks are owed to Robert Skelton. He represents the highest ideal of what a curious mind and a generous heart can do.

The painstaking research of past curators of the MFA's South Asian collection, including Pratapaditya Pal, Milo Cleveland Beach, Vishakha Desai, Darielle Mason, and Joan Cummins, has been a critical resource in the compiling of this book, as has the generous feedback of scholars and curators from other insti-

tutions. Sonal Khullar was instrumental in working out the volume's overall approach. Subhashini Kaligotla also offered helpful advice about the conceptual framework.

Thanks are owed to Chase McHugh and Francesca Butterfield for helping to create files bulging with relevant literature and documentation on the objects treated in the book, and for composing first drafts of several entries. New information was uncovered about certain objects, resulting from fruitful exchanges with Molly Emma Aitken, Allison Busch, and Sheldon Pollock. Harshita Mruthinti Kamath, M. David Eckel, Susan Bean, and John Henry Rice generously read chapters, providing crucial advice at various stages.

I have long hoped to see a South Asian art volume for the MFA Highlights series, and I am very grateful to those at the MFA who worked with me to make it happen. Special thanks go to Jodi Simpson for her sensitive editing of the text, Jennifer Snodgrass for overseeing the whole project, Diana Sibbald for guiding it through production, and Christina Yu Yu, Matsutaro Shoriki Chair of the Art of Asia Department, for her constant encouragement. Thanks also to Pam Parmal, Chair and David and Roberta Logie Curator of Textile and Fashion Arts, who enthusiastically collaborated with me to ensure that textiles were represented by the publication.

Finally, thanks are owed to Nalini and Raj Sharma, Monica Chandra and Nitin Nohria, and Steve and Barbara Gaskin for their crucial support of this book. I am grateful that they have made it possible for the Museum to make the collection of South Asian art accessible to the public in this new way.

Laura Weinstein
Ananda Coomaraswamy Curator of South Asian and Islamic Art

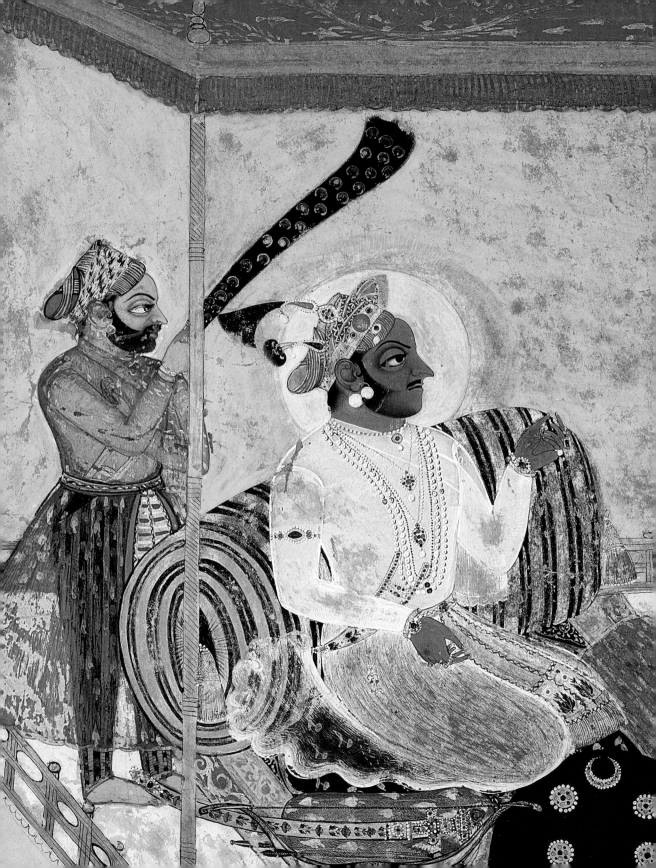

Arts of South Asia: Through and Beyond Binary Thinking

South Asia is a vast geographic region that ranges from the island of Sri Lanka in the south to the Tibetan Plateau in the north, and from Afghanistan in the west to the northeastern states of India in the east. Great diversity in climate and landscape, natural resources, and accessibility by trade routes has led to tremendous variation in local cultures. Along the floodplain of the Indus River in modern northern India and Pakistan, one of the world's oldest urban civilizations emerged, known as the Indus Valley Civilization (2600 BCE–1700 BCE). Farther south, the fertile Ganges basin gave rise to powerful states such as the Maurya empire (321 BCE–185 BCE) and the Mughal empire (1526–1857). These kingdoms unified great portions of the immense landmass of South Asia politically and, to a certain extent, culturally. In many epochs, however, South Asia has been the site of politically, culturally, and linguistically distinct regions. Today it is home to speakers of several hundred languages.

Hinduism, Buddhism, and Jainism, three of the world's great religions, emerged in South Asia and at times bonded together even individuals living in distant parts of the region. Islam entered South Asia as early as the seventh century CE, soon after that religion's founding. The Arab merchants and travelers who brought Islam to South Asia were just one of many groups who ventured to the region over the course of the last two millennia, contributing to and shaping its history and character. The arrival of European traders between the fifteenth and eighteenth centuries, leading to the absorption of much of South Asia into the British empire in 1857, was surely among the most impactful of these encounters. The introduction of European systems of knowledge formation and political domination have continued, long after the end of British imperialism, to affect the way life is lived in South Asia.

This book investigates one particular pattern of European thought that has had a deep impact on the study and understanding of cultures that emerged in South Asia: binary thinking, or framing things in contrasting pairs. This is an age-old practice as well as one that continues to be widely employed today.

Dualities—day and night, male and female, city and countryside, East and West—help people to organize ideas about the world into simple and distinct sets of two.

Binary concepts do exist in a wide range of South Asian traditions. For example, within several South Asian religions dualistic ways of understanding the self and the cosmos, or male and female, are framed so that followers of these traditions understand that their ultimate goal should be to transcend these dualities and achieve *advaita*, or non-duality. Exploring such conceptual pairs can be illuminating, as long as we are careful to see them on their own terms and not as South Asian corollaries of Western concepts.

Western forms of dualistic thinking have been entering South Asia since at least the start of the early modern period. Many took hold during the era of British colonization, as European merchants, officials, scholars, artists, and many other types of people—art historians and archaeologists included—deployed binary concepts in their effort to build knowledge about the region. The application of Western dualisms outside of the cultural world in which they emerged, as if they were universal truths, often led to oversimplification and limited understanding. Even worse, it exaggerated differences, leading to a belief in an "unbridgeable chasm" between East and West, outlined by the critic Edward Said.

Certain Western binaries have been applied with particular frequency to the study of South Asian art. *Art* and *craft* is the first pairing tackled by this book. Binary thinking often builds in dominance and hierarchy, and the art/craft duality is one that privileges certain forms of art over others, with constraining results. It causes us to overlook many important and beautiful objects and artistic traditions, and to elide indigenous systems of artistic value. In addition, it degrades the very notion of art by suggesting it belongs only to elites.

The second pair of concepts is that of *sacred* and *secular*. Rooted in ideas that emerged during the European Enlightenment, this duality assumes that sacred and mundane aspects and arenas of life are separable. The objects examined under this binary pair consistently refute this notion, which is fundamentally incompatible with most forms of South Asian religion and philosophy. Many of the featured works of art do, however, reflect ways that thinkers in South Asia have explored the relationship between the divine and the ordinary world.

Next we look at the notion that *Hinduism* and *Islam*, two major South Asian religions, are distinct and, in some essential way, opposed to each other. This reductive mode of thinking glosses over all the ways the religions of South Asia overlap and inform one another. In addition, the Hindu/Muslim duality is so dominant that it can lead us to overlook the many other faith traditions in South Asia. Works of art bear witness to the intricacy of South Asia's sacred landscape.

The fourth conceptual pairing is one that is ingrained in the Western practice of art history: *real* and *ideal*. For a long time, this binary opposition had one clearly positive pole and one negative pole, downgrading any non-mimetic art to "folk art," "craft," or another subordinate category. There are important distinctions that can be made between works of art that are "realistic" and those that are highly stylized, but South Asian traditions do not consistently elevate one above the other. The reasons why artists use certain modes of depiction must be looked at closely, as they are rooted in the goals and the context in which the artists were working.

Male and *female* is one of the most ancient and viscerally felt pairings, and there are many South Asian traditions in which a contrasting role for each sex is cast. But South Asian art provides little satisfaction to those looking to identify fixed gender roles across time and space; what the artworks offer up instead is what some writers refer to as "both/and." In other words, male and female at times play opposed roles, but they also switch roles or shift or blend together.

The final chapter examines objects that can help us consider the conceptual pairing of *local* and *foreign*. While some of the works of art reflect artistic practices and traditions that were found in only one part of South Asia and produced objects for local use, many are not so geographically isolated. South Asian art of the twentieth century, as well as earlier objects made for export, can illuminate how cultures come into being not only inside communities but also around their edges, where people meet and transform one another.

These Western binary frameworks are not inherently flawed, and they do not need to be immediately and completely thrown out. Some are downright counterproductive, but others provide a helpful guide to our thinking, if applied with an awareness of their limits. Once dualities have been made visible, it becomes possible to recognize the ways in which they constrain thinking and to start opening up other avenues of understanding. Unpacking these conceptual pairs makes the study of artworks from South Asia all the more fruitful and exciting.

Note: This book uses the term "South Asia" to refer to India and the countries that immediately surround it. The place of production of each artwork is given according to modern national boundaries.

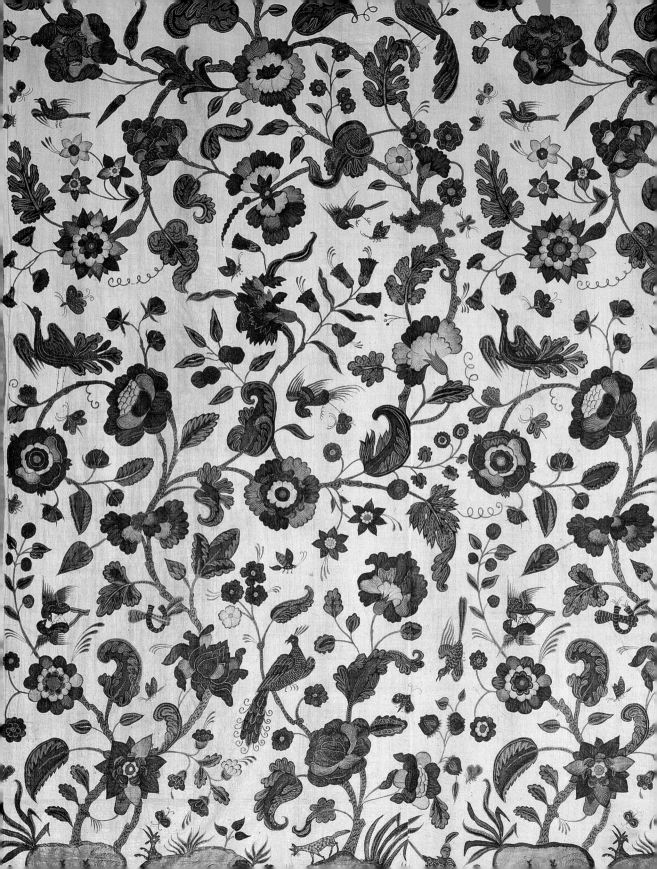

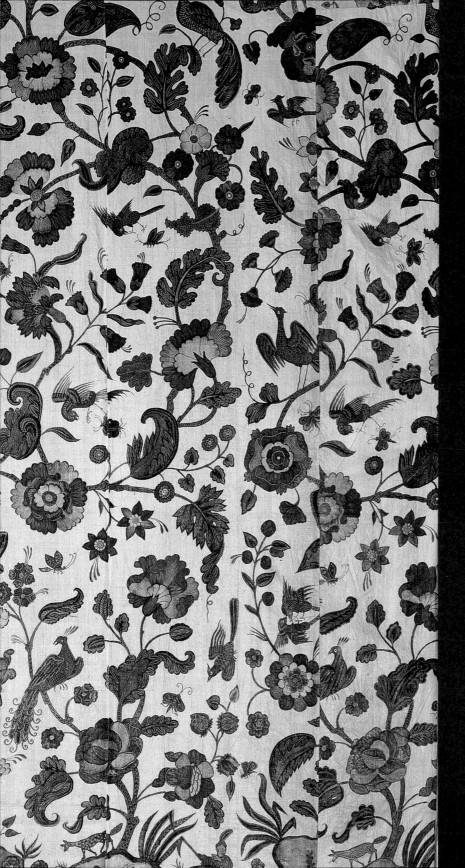

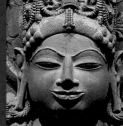

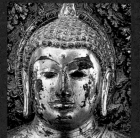

Art/Craft

The arts of South Asia take myriad forms, from stone sculptures and ivory carvings to painted textiles and illustrated manuscripts. Some art forms are found across the Indian subcontinent; others are produced within a single locality. Some are made by individual artists, and some are made by workshops. Some are intended to last forever, while others are almost immediately destroyed.

This variety is not always evident in books on South Asian art or in the displays of art museums, which tend to emphasize sculpture, painting, and architecture. The dominance of these three forms reflects a concept of art that has its roots in Europe, where their status as art was confirmed during the Renaissance. At that time, only these three art forms were believed to truly embody the heights of human knowledge, creativity, and morality; others came to be considered secondary and eventually were known as handicrafts or works of applied art rather than fine art. This distinction became so embedded in Western thought that it has sometimes been seen as a universal rule rather than the creation of a particular cultural moment.

This essentially European notion of an art/craft binary was brought to South Asia during the nineteenth century, when Europeans used it to classify the products and manufactures of the region, which became a British colony in 1858. This interest was rooted not only in a desire to profit from South Asia's natural and other resources but also in a determination to improve English industrial design. South Asia was seen, in this period, as a place where preindustrial traditions of craftsmanship, of great interest in England under the influence of the Arts and Crafts movement, were still alive and could be protected, studied, and emulated.

In the mid-nineteenth century, the British-run art schools and museums that opened in cities such as Calcutta (now Kolkata), Madras (now Chennai), and Bombay (now Mumbai) directly reflected these ideas. At these schools, instruction was focused on the skills needed to produce and improve South Asian "crafts" (for example, woodwork, ceramics, metalwork), along with technical training (including architectural drawing, surveying, engraving) that the British believed

would improve "native" taste and reasoning. School directors intended to preserve craft traditions—seen as beautiful but merely decorative—and adapt them to contemporary commercial markets, furthering the moral mission of British colonialism to bring progress to India. The refinement of taste that students at the school were to experience would, it was thought, eventually prepare them for the understanding of "fine art." This loaded term was considered to mean European paintings or sculptures that, through the imitation of natural forms, embodied and expressed moral ideas or dealt in original ways with historical or poetic subjects.

Colonial museums made clear that those South Asian visual and material practices that were worthy of preservation and study were decidedly in the domain of craft. Objects were collected from across India to represent the widest possible range of "Oriental" designs, decorative traditions, and manufacturing processes. Even today—in part because of Mahatma Gandhi's emphasis on the value of village culture and rural life—the preservation and promotion of traditional crafts is taken seriously by government and nonprofit institutions alike.

At the turn of the twentieth century, however, certain individuals began to argue that among the products and wares of South Asia were some things that ought to be valued as fine art. Institutions such as the Indian Museum in Kolkata, for example, began to collect and display the seminaturalistic paintings produced during the period of the Mughal empire (1526–1857). Books like E. B. Havell's *Indian Sculpture and Painting* (1908) began to shift opinion on the moral and artistic quality of these types of objects. Nationalism fueled this development, as a claim to equal or superior status for art and culture of South Asia was a critical part of nationalist thought. One way this claim was articulated was by arguing that compared to Western art, the art of the subcontinent was more concerned with what lies beneath and within—in other words, it held the moral value required by the European definition of fine art. South Asia's arts began in this way to be gradually incorporated into the category of "art." However, the art/craft divide kept its foothold in society and thought, as did many of the conceptual schemas introduced by colonialism.

Although the art/craft binary even today haunts attempts to write about or categorize South Asia's arts, scholars have for over a century sought indigenous concepts of art and aesthetics that could perhaps displace it. An early effort was that of Ananda K. Coomaraswamy, the founder of the MFA's collection of South Asian art and a prominent art historian and nationalist. Coomaraswamy proposed a new binary to replace art/craft: *marga* and *desi*. Both words appear in ancient Sanskrit literature. *Marga* means a way or path that leads to spiritual liberation, and Coomaraswamy equated it with artwork that was rooted in an

ancient and spiritual tradition. *Desi* refers to a path within a more local space or place, and was equated with art that represents a more short-lived and localized tradition that is also less deeply engaged with spirituality. Although this binary is rooted in South Asian concepts and terms, a scholarly consensus never solidified around it. Nevertheless, it represents an important moment in the effort to replace Western modes of thought ill-suited to South Asian art with ideas rooted in South Asia's own thought traditions.

Today it is clear that there can be no absolute definition of *art* or *craft*. However, one can study how people in a given context understood the relationships of different art forms to one another. For example, the ways that textiles were made, preserved, and used show that they are among the most important forms of art within the region's aesthetic, ritual, and economic systems.

Indian aesthetics also offers insights into how different forms of art were understood in the region at different times. Among the texts and treatises in various languages that survive on the subject, one concept that appears again and again is *rasa*, the emotional response that occurs in a person who witnesses a work of art of any kind (visual, literary, musical, dramatic, and so forth). Although the texts do not always agree, in general it seems all types of objects can give rise to *rasa*. The importance of this particular aspect of art to thinkers in the region, and the way it cuts across categories like *fine art* and *craft*, suggests that it might be a useful analytical tool.

One final development that has helped to break down the art/craft binary is the effort of scholars to uncover the complex methods and meanings that can be hidden by an apparently unrefined surface. Repeating patterns, for example, need not mean a simplistic set of ideas or techniques. Likewise, the rich knowledge traditions embedded in metalwork, jewelry, and ceramics are being increasingly explored. Painting, sculpture, and architecture remain important objects of study, but we can learn more when we set aside the assumption that they were understood in their original context as art.

Seated Buddha with screen and canopy

9th century CE

Nagapattinam, Tamil Nadu, India

It could easily have been a sculpture like this one that was projected on the wall when, in London in 1910, the art historian and arts administrator E. B. Havell gave a speech about the problems of art education in India. He was disturbed that students were being taught that "Indian applied art is admirable and Indian fine art barbaric." The speaker after Havell, the writer and promoter of India's applied arts Sir George Birdwood, had a different perspective. Gesturing toward the projected image of a sculpture of a meditating Buddha that had been supplied as an example of fine art, Birdwood said, "a boiled suet pudding would serve equally well as a symbol of passionless purity and serenity of soul. It is vain to argue that such imbecilities are objects of 'fine art' because of the thoughts and emotions they excite in the devout."

This sculpture of the Buddha was, in fact, made for the devout, in one of the most prosperous and learned of the later centers of Buddhist practice in South Asia: Nagapattinam, in the modern state of Tamil Nadu. A southern Indian coastal city, Nagapattinam thrived during the period of the Pallava and Chola kingdoms (about 550–728 CE and 862–1310 CE, respectively). The city's Buddhist institutions received support from local and overseas rulers and from merchants and other donors, sometimes in the form of Buddhist sculptures. This particular Buddha—made from gilt bronze, with silver inlaid eyes—is among the greatest Buddhist sculptures known from southern India. The smooth, broad contours of the body of the Buddha, typical of Nagapattinam, create a striking contrast with the ornate and almost ethereal throne back. At one time, the Buddha would have been accompanied by two bodhisattva attendants slotted into the throne back, and the entire ensemble would have rested upon a throne seat.

Gilt bronze with silver inlay

Buddha: 60 x 30.5 x 20.3 cm (23⅝ x 12 x 8 in.);

canopy and screen: h. 81.9 cm (32¼ in.)

Buddha: Keith McLeod Fund 1970.3

Canopy and screen: Marshall H. Gould Fund 67.4a, 67.4b

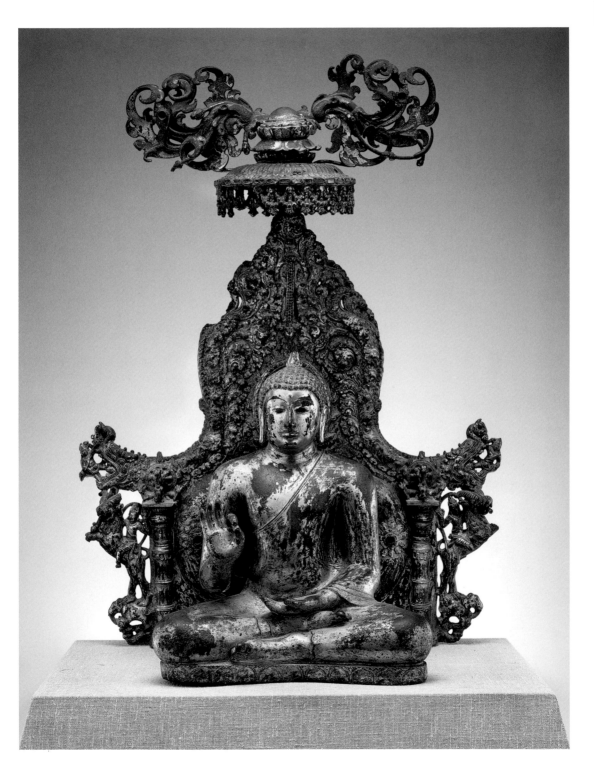

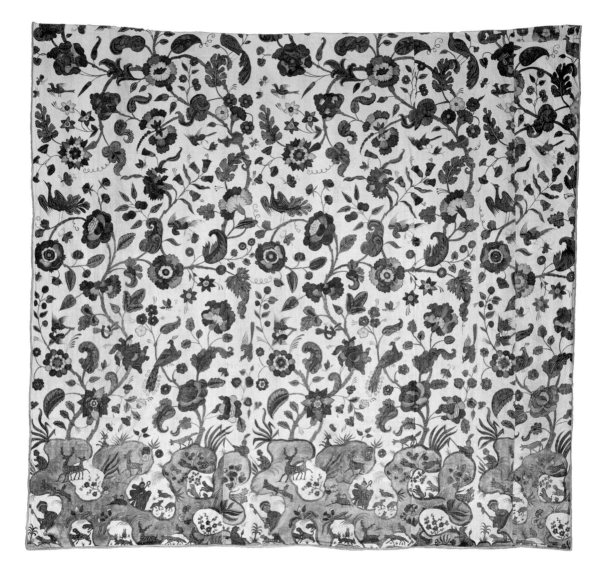

Curtain, late 17th century
Probably Gujarat, India

With a brilliant polychromatic palette, this curtain shows a rocky landscape full of deep, craggy canyons. Wandering hunters and herders stalk a range of wild animals that slip into and out of view. Sprouting from the rocks are slender, curving branches bearing insects and birds as well as flowers in a range of pinks, oranges, and pale blues. In early modern South Asia, this type of imagery was understood as directly linked to its natural counterpart: a flower garden. A verse said to be composed by the Mughal emperor Jahangir (r. 1605–27), for example, links floral carpets to gardens and describes nature as being able to weave its own beauty. A textile artist, likewise, could be seen as a skilled gardener.

This curtain exemplifies a type of South Asian art highly valued in Europe long before the period of British colonialism in the region (1858–1947), though it was not at that time considered art. Made in Gujarat, textiles like this were imported to Europe in massive quantities by the seventeenth century. There, they were called chintz and were used for curtains, furnishings, and bedspreads, among other things. To the English, these textiles exemplified the excellence of South Asian "applied arts" or "crafts." In the early twentieth century, this particular curtain was in the collection of Lady Catherine Ashburnham of Sussex, England.

Although great skill and imagination were necessary for the making of this object, no name to which we can attach its production survives. Western art history prizes the notion of an artist as a star-like individual who is the beneficiary of divine inspiration or a genius who breaks with tradition to turn art in an entirely new direction, but in South Asia artists are often defined quite differently. In many forms of art—such as, for example, this curtain—a great artist is one who is a superb and subtle interpreter of an existing visual tradition or style.

Cotton plain-weave, hand-painted, mordant- and resist-dyed; silk damask lining
246 x 257.5 cm (96⅞ x 101⅜ in.)
Samuel Putnam Avery Fund and Gift of Mrs. Samuel Cabot
53.2201

Vishnu, early 11th century
Probably Madhya Pradesh, India

This image of the Hindu god Vishnu, carved out of sandstone, is ravishing in its crispness and in the stark contrast created between the smooth, solid flesh and the precise detailing. Although the hands that held identifying objects are now missing, other details of the sculpture reveal clearly its identity as Vishnu: his four arms, the diamond-shaped mark of divinity on his chest, his conical crown, and the remnants of his long garland. Vishnu is one of the major deities of Hinduism, and his devotees consider him the supreme being from which all things emerge.

Although their status as great works of art today may seem self-evident, sculptures of Hindu gods like this one were not recognized as such by Europeans during the colonial period. Joseph Crowe, a painter who taught art in India during the mid-nineteenth century, gave a dismal (and typical) assessment of this art form when he wrote that "the grotesque images which libel the shapes of men and animals in all parts of a Hindoo temple, are irredeemably bad." To Europeans these sculptures appeared neither to embody profound ideas nor to accurately depict the human body, and as a result they were seen as mere decoration at best.

When it was originally produced, a sculpture like this one would not have been understood as a work of art in the way we use that term today. It probably once adorned a niche in the outer wall of a large Hindu temple, similar to the monumental buildings that stand even today at the famed site of Khajuraho in Madhya Pradesh. It would therefore have been understood not as a singular work of art but as part of a sacred architectural fabric that included hundreds of other sculptures of gods and heavenly beings. The towering superstructure over the sanctum of a northern Indian Hindu temple is often covered with sculptures that together suggest a heavenly abode suitable for the god worshipped within.

Sandstone
119.3 x 46.6 x 33 cm (47 x 18⅜ x 13 in.)
David P. Kimball Fund 25.438

Pendant depicting the ten incarnations of Vishnu, early 18th century
Jaipur, Rajasthan, India

Highly decorative enamels are often associated with Indian jewelry, but the technique of champlevé, in which depressions are carved out of a metal base and then filled with enamel, did not originate in the Indian subcontinent or neighboring regions. The tradition was introduced to various Indian courts by master jewelers from Portugal during the sixteenth and seventeenth centuries. Once in the hands of Indian artists, however, the style exploded, becoming ever more inventive and technically demanding. By the eighteenth century, enamelwork with religious themes became extremely popular, yet few contain the number and quality of the figures seen here.

On the back of this pendant, an artist has created a supremely compact depiction of the incarnations (avatars) of the Hindu god Vishnu. Featured in the central panel is the opening scene from the sacred Indian text the *Bhagavad Gita*, in which Krishna delivers teachings to his follower the warrior-hero Arjuna. Krishna was the most popular avatar of Vishnu in Rajasthan from the sixteenth century onward, and his importance is indicated by his central position. Surrounding this scene (starting at center right and moving clockwise) are Vishnu in the forms of a fish, a tortoise, a dwarf, Kalki, Parashurama, a boar, Narasimha, Rama, and Jagannatha.

It is rare to find such a complex visual program on an enamel surface of such a small size. It is likely the result of a team of artists challenging themselves to relate a rich chapter of Hindu mythology in miniature. This Vishnu-themed side of the pendant would have lain against the wearer's chest; the opposite and more flamboyant side would face outward. The gems it bears (diamonds, rubies, emeralds, and a large yellow sapphire in the center) may have been seen as carrying powers of healing and protection.

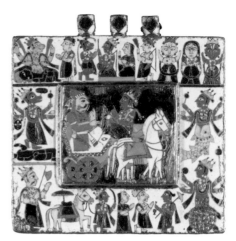

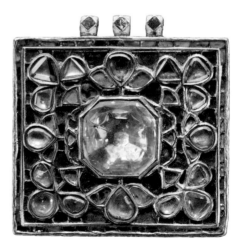

Front: gold, yellow sapphire, diamond, emerald, ruby; back: gold and enamel
4.9 x 4.8 cm (1⅞ x 1⅞ in.)
Otis Norcross Fund 39.764

Krishna and Dhenuka, about 1650
Page from a *Bhagavata Purana* series
Gujarat, India

This painting comes from a series of depictions of stories from the *Bhagavata Purana*, a text particularly important to Vaishnava Hindus, who worship Vishnu as the supreme being. One episode relates that once, when Krishna—both an avatar of Vishnu and a god in his own right—and his companions were collecting fruit in an orchard, a demonic donkey named Dhenuka used his hind legs to kick Krishna's brother in the chest. As the donkey prepared to repeat the blow, Krishna grabbed him by the hind legs and threw him across the orchard. Dhenuka's dying body shook the trees as it flew past, causing fruit to fall into the hands of Krishna's friends. In the lower left of this painting, Krishna grabs Dhenuka; the rest of the work is filled with trees, cows, cowherds, and birds, all set against a plain ground. Though their forms are simplified, the trees are carefully differentiated—pomegranate, palm, and cypress each display their most characteristic attributes.

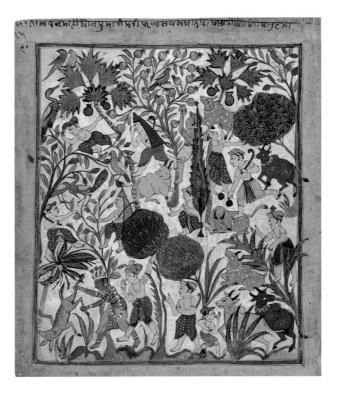

The series of paintings to which this work belongs, once owned by a man named Tula Ram, is known for the uniquely even way that forms are dispersed across the page without any semblance of spatial recession. These features typically characterize textiles—in particular, the kinds of embroidered textiles that were abundantly produced in Gujarat, a major trading center, in the eighteenth century. The names of the artists are unknown, but we can speculate that they worked on textile and painting designs, which could explain the appearance in painted form of an aesthetic associated with textiles. This coming together of an art form associated with craft (textiles) with one associated with art (painting) collapses the art/craft binary, exposing its limitations when applied to South Asian art.

Opaque watercolor and gold on paper
26.4 x 22.8 cm (10³⁄₈ x 9 in.)
Gift of John Goelet 60.636

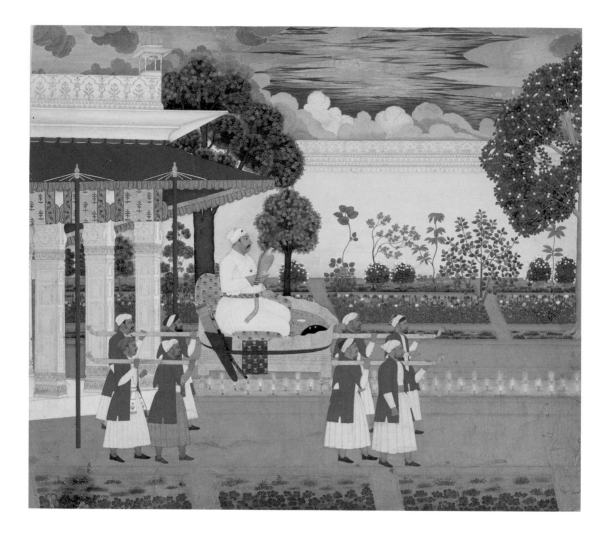

Muhammad Shah viewing his garden at sunset, about 1730
Attributed to Chitarman II, known as Kalyan Das (active about 1700–1745, Indian)
Northern India

This painting is the essence of refinement. Crisp and highly detailed forms, as well as precisely defined spatial elements, reflect the aims of artists in imperial workshops during the period of the Mughal emperor Muhammad Shah (r. 1719–48): precision and drama. Although it is unsigned, scholars believe this work was made by the artist known as Chitarman II, the most prominent painter of the eighteenth century in South Asia. He was the chief painter serving Muhammad Shah, and though his work clearly belongs within the Mughal painting tradition, which prized naturalistic space and color combined with hierarchical representations of rulers and elites, he was undoubtedly an innovator. Among the most striking features of his personal style is the extreme flatness and almost grid-like nature of his compositions, which seem as though they are formed of interlocking geometrical forms.

Among the most powerful depictions of a garden in any artistic tradition, this unusually large painting combines chromatic intensity with areas of brilliant white. Vibrant orange and green colors are made still more powerful through the generous use of gold. Vegetation, treated in a hyper-naturalistic manner, and carefully rendered portraits link the otherwise fantastic image to reality.

This painting was made during the peak of the artist's career, a period in which he made several portraits of the emperor in his "private" life, depicting him carrying out daily activities in the presence only of servants and advisers. This is the most famed of that group of works. The access that Chitarman had to the emperor is evident not only in the subject of his paintings but also in the way he signed his paintings. He often called himself *khanazad*, or "house-born," meaning that he was born into a family that was already in royal service.

Opaque watercolor and gold on paper
38.6 x 43.4 cm (15³⁄₈ x 17¹⁄₈ in.)
Arthur Mason Knapp Fund 26.283

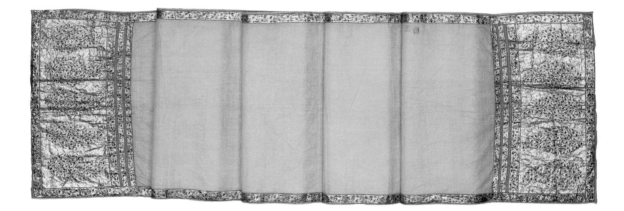

Sash (*patka*), 18th century
Deccan region, India

The art/craft binary often leads to functional objects being thought of as craft rather than fine art, but an object like this *patka* provides a different perspective. Though it was made for use as a garment—to be worn as a sash or a girdle—a close look reveals that aesthetics were equally or perhaps even more important than utility to the artist who made it. The edges and ends of the *patka* are decorated with wing-casings from jewel beetles, so called because of their iridescent coloration. The casings are brittle and fragile, and moving around while wearing the *patka* would have required extreme care.

For elites in South Asia between the sixteenth and eighteenth centuries, *patka*s were essential parts of courtly attire (see p. 100 for an image of a courtier wearing one). The finest were made with expensive and technically complex materials, and were intended to project the political status, wealth, and good taste of their wearer. The ends of the *patka*, which hang down conspicuously in front of the body, tend to be more elaborately and sumptuously ornamented than the central area. Here they are decorated with cone-shaped floral motifs (*boteh*) and undulating vines on a gold ground, all studded with the delicate beetle wing-casings.

Cotton and silk plain-weave with silk and gold- and silver-wrapped thread discontinuous supplementary patterning wefts, applied beetle wing-casings
Length: 367.7 cm (144¾ in.)
Denman Waldo Ross Collection 24.433

Painted cotton (*rumal*), third quarter of the 17th century
Andhra Pradesh, India

The imagery on this *rumal*, or painted cotton, a rare and extraordinarily beautiful example, draws on the rich world of Persian and Islamic culture, which became deeply interwoven with South Asian culture from the thirteenth century onward. Here two angels dance in its central field while eight others kneel and play musical instruments in a lush wilderness replete with birds and a herd of gazelles.

Angels, semidivine winged figures, appear throughout the Qur'an as well as in classical Persian literature and mystical thought. The most important is the Archangel Gabriel, who is understood to have delivered to Muhammad the divine words from God that later became the Qur'an. Angels are depicted in a range of settings: they play trumpets on the Day of Judgment and accompany Muhammad on his ascension to heaven; they frequently appear in paintings of verdant gardens that evoke a paradise or heavenly garden but also suggest the types of elaborate yet earthly gardens built in sixteenth- and seventeenth-century South Asia by Mughal rulers, sultans of the Deccan, and others. This textile, which may have been used as a cover for an important or ceremonial gift, probably evoked in its owner's mind topics ranging from paradise and pleasure to the rewards received by the deserving on the Day of Judgment.

Cotton plain-weave, painted, mordant- and resist-dyed
67.3 x 82.5 cm (26½ x 32½ in.)
Gift of John Goelet 66.230

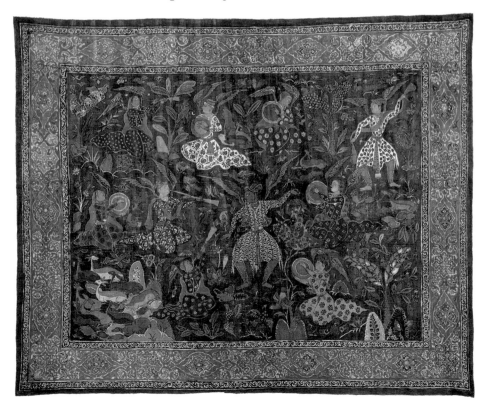

Maharana Jawan Singh of Mewar worshipping an icon, about 1830
Udaipur, Rajasthan, India

The style and composition of this richly detailed painting links it to the temple town of Nathadwara, near the capital of the Rajput state of Mewar. Pilgrims who visited the temples of Nathadwara frequently purchased locally made depictions of the town's most famous icon, an image of Shri Nathji, a form of the god Krishna. These paintings were often slapdash and were produced in large numbers as souvenirs for the many pilgrims who moved through the town; the images could also be placed on a home shrine and used to worship the god.

Maharana Jawan Singh (r. 1828–38) of Mewar belonged to a ruling family that promoted the worship of gods like Shri Nathji. Beginning around 1800, family members had themselves depicted before these powerful icons in paintings. This particular painting shows Jawan Singh at the bottom left and two priests at the bottom right. They stand before a richly adorned sculpture that may be Shri Charbhuja, a *svarupa*—a "self-made" image, one believed not to have been sculpted by any human—of Vishnu. Many *svarupa* have been found in caves or at the bottom of ponds in southern Rajasthan; these icons were moved to temples where they continue to draw large crowds of pilgrims.

This image has the sophistication of paintings made at the court of Maharana Jawan Singh, but it is composed in the manner of a Nathadwara painting. In fact, it may be that the ruler ordered an artist from his royal workshop to create this image so that he could have a Nathadwara-style painting of the same level of quality and precision as the rest of the paintings being made at his court. If this is so, it may reflect not an art/craft binary but rather a spectrum of styles ranging from very rough to highly refined that were considered appropriate for sacred imagery.

Opaque watercolor, gold, and silver on paper
40.2 x 30.2 cm (15⅞ x 11⅞ in.)
Denman Waldo Ross Collection 28.57

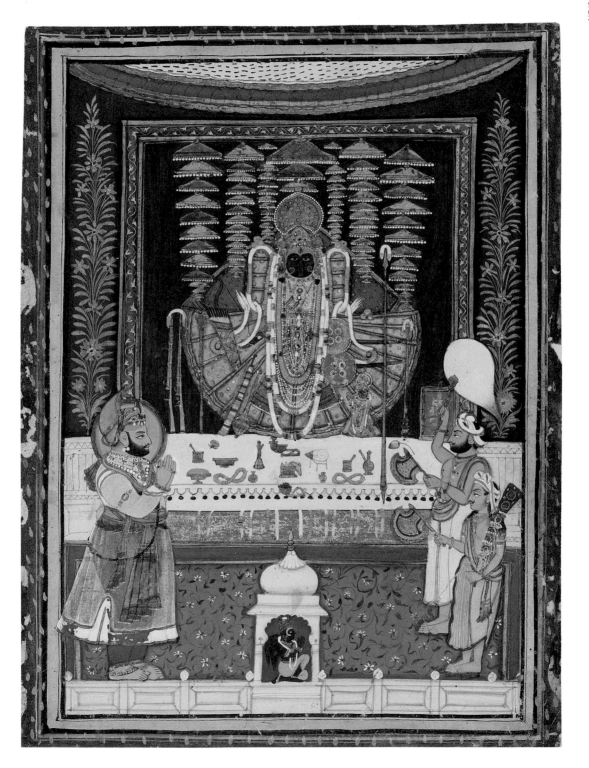

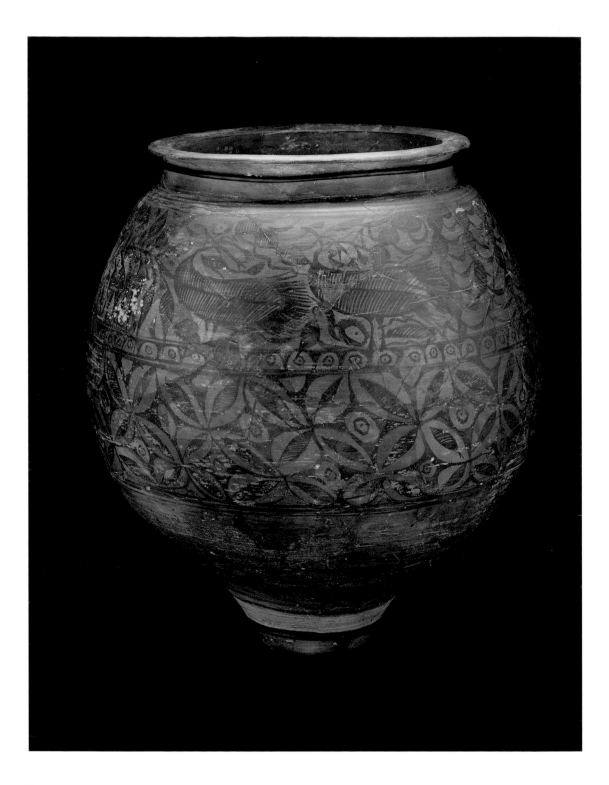

Jar with birds, 2600 BCE–2000 BCE
Chanhu-Daro, Sindh, Pakistan

With a round body and narrow foot, this large jar has
the look of a ripe piece of fruit. Wrapping its exterior
are painted bands, one of which repeats a bird that is
perhaps a peacock. In the lower register, a deceptively
simple pattern of interlocking circles on two levels
can also be seen as four-petaled flowers. This jar
would have been a highly prized object within a com-
munity belonging to the earliest urban civilization in
South Asia. Emerging around 2600 BCE in the Indus
River valley in Pakistan and northwestern India, the
Harappan culture, the most widespread culture of
the Indus Valley Civilization, was highly advanced
for its time and was shared by communities across
more than 750,000 square miles (1.9 million square
kilometers). Between about 2600 BCE and 1900 BCE,
Chanhu-Daro, located in present-day Pakistan, was
a prosperous settlement of the Indus Valley Civiliza-
tion, with buildings of baked brick, a complex drain-
age system, and a flourishing bead-making industry.

Beads, weights, pottery vessels and figurines,
and metal objects were excavated at Chanhu-Daro
by the Museum of Fine Arts, Boston, and the Ameri-
can School of Indic and Iranian Studies in 1935–36.
Though the remains of brick foundations indicate
that architecture was a serious endeavor in this
society, there is no evidence for major production of
sculpture or painting at Chanhu-Daro. However, the
objects that were made suggest a culture with a well-
developed aesthetic.

Terracotta; buff-colored clay painted with red slip and
black decoration
48.3 x 38.1 x 38.1 cm (19 x 15 x 15 in.)
Joint Expedition of the American School of Indic and Iranian
Studies and the Museum of Fine Arts, 1935–1936 Season
36.2977

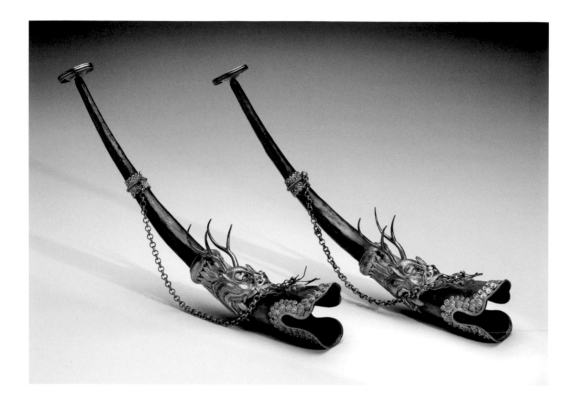

Pair of trumpets (*rkang-gling*), about 1900
Tibet

The bells of these two trumpets were made to appear as if they are emerging from the mouths of *makara*s, mythical beasts that combine the forms of crocodiles, elephants, dragons, lions, and other animals. *Makara*s appear throughout South Asian art, sculpted from stone as part of the architecture of Hindu and Buddhist temples and monasteries, and worked in metal on objects like these trumpets and the elephant goad on page 38.

While *makara*s often feature on entrances and gateways as guardians, they have a range of associations depending on the context in which they appear. In Tibet, they can represent strength and stability. Trumpets of this kind (known as *rkang-gling*) are played in that region as part of orchestras of eight to twelve wind and percussion instruments. These musical ensembles are a critical component of some Tibetan Buddhist rituals.

Among the features of this unusually elaborate pair are wiry whiskers and forked horns, as well as two rows of wave motifs that curl around the edge of the bell, hinting at the *makara*'s affinity with water. Amazingly, the bodies of the trumpets are made in three telescoping parts, allowing them to be partially collapsed for easy transport.

Copper and silver
47 x 8.9 x 14 cm (18½ x 3½ x 5½ in.)
Harriet Otis Cruft Fund 2014.1023.1–2

Casket, 1543–55
Kotte, Sri Lanka

The dense motifs covering every surface of this casket, hewn from creamy ivory, achieve a beautiful yet subtle effect. The only color comes from restrained placement of ruby, gold, and turquoise bands separating sections in a way that mimics the posts and lintels of a building. This is no ordinary house, however; if anything, it is a palace—one inhabited by dancers, mythological creatures, celestial musicians, and even a goddess holding two lotuses.

The rectangular shape and pitched lid of this casket are derived from European boxes, though it is known to have been made in Sri Lanka. Sri Lankan artists in the sixteenth century produced many items designed to appeal to European taste, though not to the European notion of fine arts per se. Beautiful objects made of rare or precious materials are and have been valued nearly universally, though in Western societies they have generally been considered luxury goods rather than art. This box is so exquisite in its materials and making that it calls into question this hierarchy.

Ivory boxes and other beautiful and expensive objects were sometimes gifted by the king of Kotte, a city in southwest Sri Lanka, to Portuguese noblemen and royalty, conveying regard and securing diplomatic relations. Ivory caskets from Sri Lanka particularly impressed royalty in Lisbon, who admired the technical skill with which they were carved and their imagery, drawn from both the Hindu and Buddhist visual worlds. This casket was likely once part of the "cabinet of curiosities" of Catherine, Queen of Portugal, who was an ardent collector in the sixteenth century—a period before the European division between fine art and craft had become firm.

Ivory, gold, glass, rubies, turquoise, and gilt bronze
10.9 x 16.5 x 10.2 cm (4¼ x 6½ x 4 in.)
Bequest of William A. Coolidge 1993.29

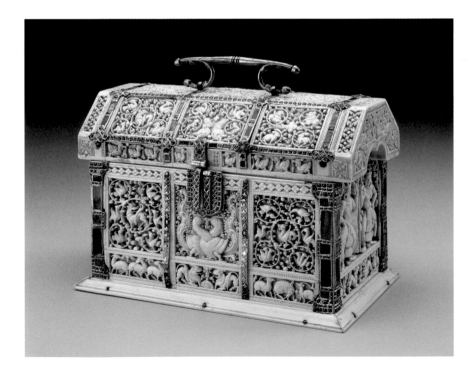

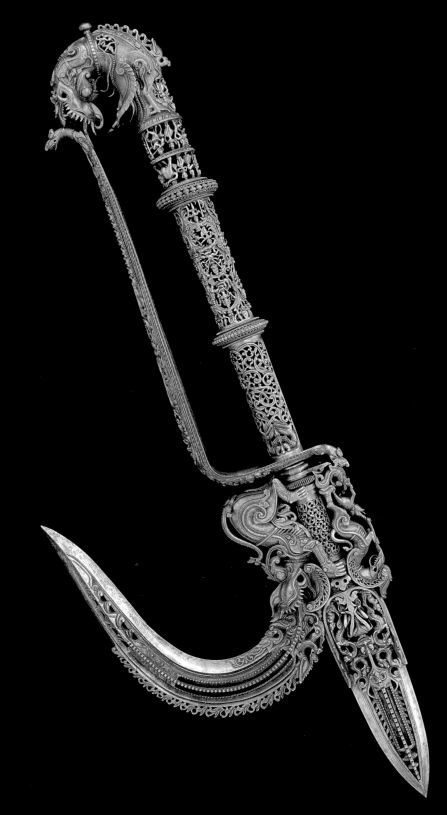

Elephant goad (*ankus*), early 17th century
Tamil Nadu, India

An elephant goad, or *ankus*, is at its most basic level
a tool for controlling an elephant. This particular
ankus, however, is not so much a tool as a sculpture:
its functional nature is overshadowed by its beauty
and complexity. Almost every surface is covered
with minute figures of Hindu deities, including sev-
eral forms of Shiva and the avatars of Vishnu. Also
featured are mythological and real creatures. The
curved point of the *ankus* emerges from the mouth of
a *makara*, while the base of the straight point rests on
the back of a lion-like *yali* with a long trunk.

This *ankus* could only have been made for ceremo-
nial display, and it was probably commissioned by
a ruler in southern India. In pre-modern South Asia,
rulers rode on elephants and carried goads during
royal and religious processions as an emblem of roy-
alty and power. A ruler's ability to control elephants
signified his capacity to control and protect the world
generally.

The emotional flavor associated with an object like
this is called *vir rasa*, or the heroic sentiment. Works
of art that arouse this response sometimes also cause
a viewer to feel pride and anger. The fierce mythical
beings that ornament this powerful tool can therefore
be seen as both enhancing the beauty of the goad and
amplifying its power to incite feelings within those
who encounter it.

Steel
70.1 × 25.9 cm (27⅝ × 10¼ in.)
Keith McLeod Fund 1995.114

Pair of ceremonial ewers and goblets, 1885–90
Grish Chunder Dutt (19th century, Indian)
Kolkata, West Bengal, India

In the latter half of the nineteenth century, silversmiths all across South Asia produced objects of European shape and function—tea services, ornamental platters, ewers—and decorated them with images of the Ganges, scenes of village life, and other "Indian" motifs. Created to suit European taste, the objects were sold mainly to British buyers in India and England. These two ewers and the goblets that accompany them are among the most impressive silver objects created in this period.

Like the steel elephant goad, the detailed surfaces of these ewers and goblets were painstakingly carved by hand. One ewer and both goblets depict the shoreline of the Hugli River, a branch of the Ganges that runs through Kolkata. The artist has taken imagery from nineteenth-century prints showing boats on the river and buildings along the bank and ingeniously applied it to the ewer so that it forms a spiral that begins at the spout and ends at the base. The other ewer depicts the Ganges in its mythological context rather than its commercial and industrial one. It shows the descent of the Ganges from heaven to earth, its fall broken by the thick locks of Shiva's hair. Like the famed seventh-century *Descent of the Ganges* relief at Mahabalipuram in Tamil Nadu, the scene shows the gods and the river within a larger environment interspersed with animals, plants, and ascetics.

Alone, either of these ewers would be an impressive artistic accomplishment. Together they are something more, showing the same river through two different lenses and, in so doing, demonstrating the critical though changing role that the Ganges has played throughout time.

Height of each ewer: 52.1 cm (20½ in.);
height of each goblet: 22.9 cm (9 in.)
Silver, interior gilt
Charles Bain Hoyt Fund and partial gift of Richard Milhender
2013.627.1–4

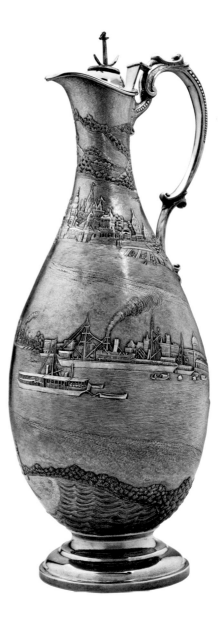

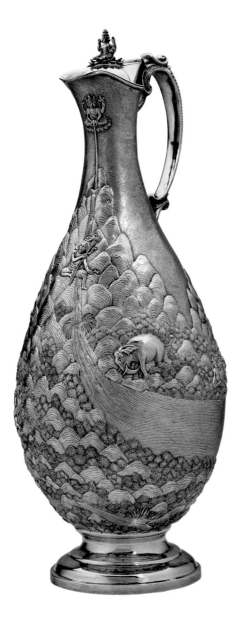
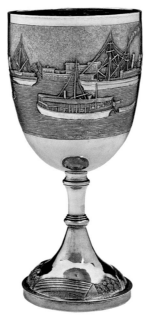
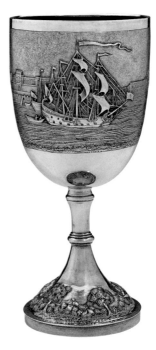

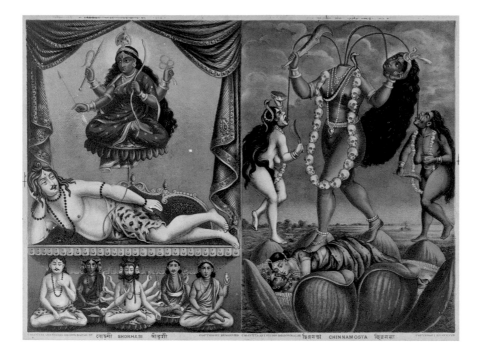

Shorhasi and Chinnamosta, about 1890
Printed by Calcutta Art Studio
Kolkata, West Bengal, India

One of the first Indian presses to create what is today often called "calendar" or "bazaar" art, the Calcutta Art Studio was founded in Kolkata (then Calcutta) in 1878. They produced lithographs—first hand-colored and later printed with color, as in this example—of Hindu gods and goddesses, along with subjects from Bengali literature. Using a German-made press, the Calcutta Art Studio initially aimed to create portfolios of fine prints for a discerning audience.

This print, produced by the Calcutta Art Studio, belongs to an early series of the ten Mahavidyas, two of which appear on each of five prints. The Mahavidyas are a group of goddesses that reflect the wide range of forms taken by Devi, the Great Goddess, according to medieval Hindu theology. Not often worshipped individually, the goddesses were ideal for the kind of high-end print series that the Calcutta Art

Studio was making in its early years. Shorhasi (upper left) is a four-armed goddess seated on a lotus that grows from the navel of Shiva. Chinnamosta (right) holds a sword and her own severed head. Compared to the flat planes of color employed in earlier mythological paintings produced in Kolkata, these images render space and volume realistically, using shading to convey the three-dimensional form of a hanging curtain or the body of a god.

Despite their use of European techniques of rendering color and space as well as the lithography process itself, the imagery of Calcutta Art Studio prints like this one jettisoned many of the aesthetic and moral connotations of European art. Rather than reflecting improved "native" taste and reasoning, the adoption of European art forms imparted to images like this one a sense that the gods and the mythic landscapes they inhabited were real.

Lithograph
41 x 51 cm (16⅛ x 20⅛ in.)
Gift of Mark Baron and Elise Boisanté 2011.2012

Bull handler, 1937
Nandalal Bose (1882–1966, Indian)
Poster from the Haripura series
Haripura, Gujarat, India

This poster is one of more than four hundred that artist Nandalal Bose designed for the 1938 meeting of the Indian National Congress Party at Haripura. The bull handler depicted may be a villager carrying out a quotidian task, but he is cast as a heroic figure, capable of taming a raging animal. Bose based the poster, like others in the Haripura series, on pen-and-ink and brush sketches of the local villagers, yet he transformed them into symbols projecting the nobility and moral strength of the new Indian character.

During the Indian colonial period, many artists began to paint in oils and to adopt the subjects and styles considered appropriate for art in Europe and America. Artists who were part of the nationalist movement, however, often spurned these imported aesthetics. Some sought to develop entirely new art forms; others wanted a return to old modes and principles of South Asian art. Still others—such as Abanindranath Tagore, who had taught Bose—adopted techniques derived from East Asian art out of a desire to join a pan-Asian movement to promote Asia's culture as unified and equal (if not greater) in depth and strength to that of the West.

For the Haripura posters, Bose chose not to use his teacher Tagore's wash techniques, instead selecting materials and techniques that were rooted in South Asian rural and folk life. On handmade paper stretched over strawboard, Bose depicted village scenes in thick tempera made from natural pigments, seeking to reflect the Gandhian notion that India's future lay in returning to, restoring, and improving rural life. The posters were shown on gates, pavilions, and walls of the living quarters of the volunteers helping to run the meeting, who were drawn from local villages. Bose's goal was to bring to the attention of villagers the beauty and nobility of village life and to thereby build the nation's moral character.

Tempera on paper
63.5 x 59.7 cm (25 x 23½ in.)
Keith McLeod Fund, 2013 2013.879

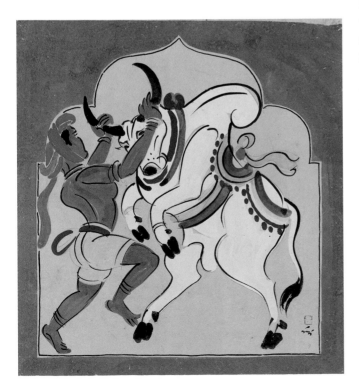

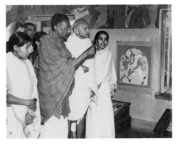

Nandalal Bose showing Gandhi the Haripura posters,
Haripura, Gujarat, India, 1938.
Gift of Mary K. Eliot and Supratik Bose.

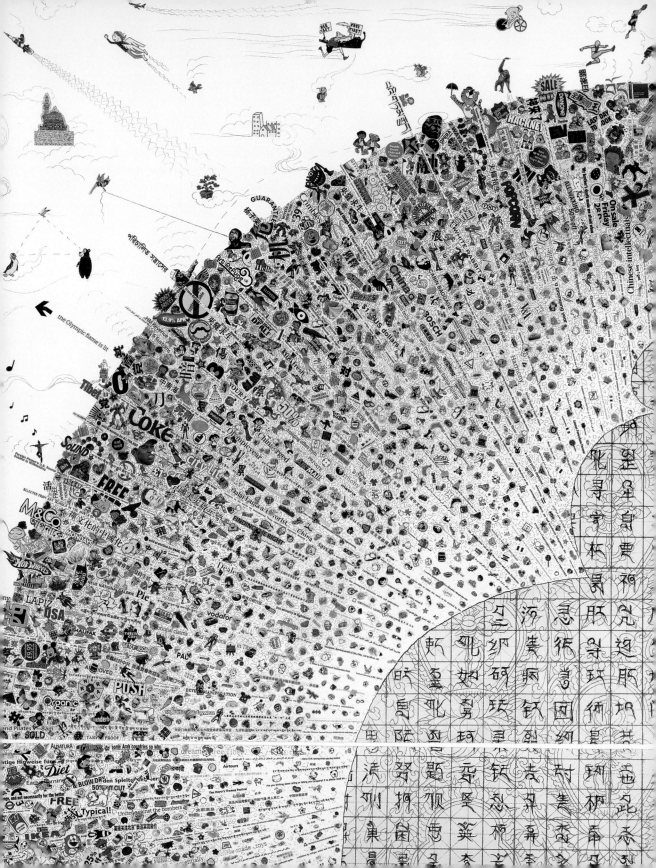

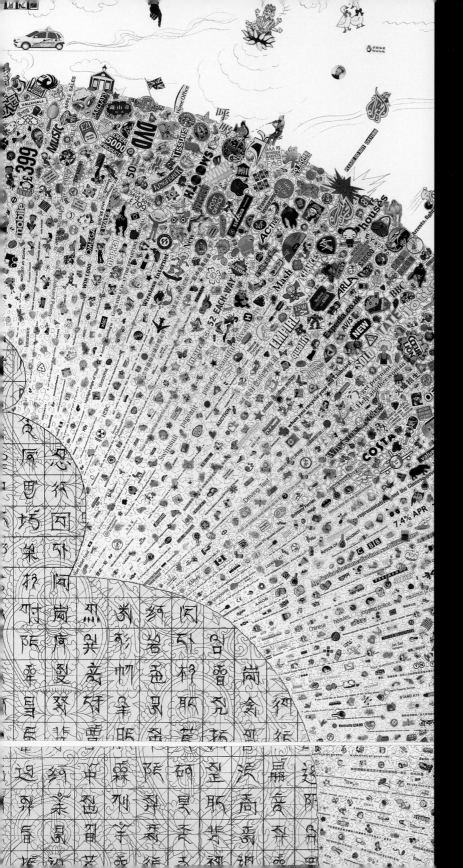

Sacred/Secular

The division of life into sacred and secular spheres is an idea that emerged within the specific cultural and social context of the European Enlightenment in the eighteenth century. The idea became so deeply embedded in Western thought in the following centuries, however, that many began to believe that a natural divide existed between the two. Art came, broadly speaking, to be seen as belonging to the secular world, a realm of experience ruled by aesthetic and philosophical principles, with little connection to matters of faith or ritual. To fit religious objects, such as medieval Christian paintings, into this conception of art, museums and art historians found ways to emphasize formal qualities over theological ones.

This process occurred in South Asia during the colonial period (1858–1947), when a history of the region's arts was drafted by European scholars along exactly these lines. Hindu sculptures, for example, that had initially been abhorred because of their association with polytheistic religion were gradually accepted into museums and art-historical texts once the argument was made, in the early twentieth century, that they could be seen as objects of beauty with spiritual overtones rather than as idols. This dynamic played out in another South Asian context slightly later, when the art historian Ananda K. Coomaraswamy categorized Mughal art as courtly and secular and therefore fundamentally alien to South Asian culture, which he saw as rooted in the sacred.

Today, books and museum installations of South Asian art often emphasize the religious symbolism of Hindu, Buddhist, and Jain sculptures, while focusing on the techniques and uses of "courtly" arts like book paintings, luxury objects, and textiles. Displays like this give the impression that there are sacred objects and secular ones, with little overlap between the two categories. This separation breaks down, however, when the objects themselves are closely examined. For example, artworks considered to be secular—portraits of rulers, illustrations of romantic tales—often bear connections to the sacred through their symbolism. Similarly, the meaning of holy objects—images of gods, ritual implements,

depictions of Hindu myths—may not fully cohere if mundane or earthly considerations, such as how they are used or their method of production, are not taken into account. As the great scholar Stella Kramrisch wrote in *The Art of India* (1954), "the art of India is neither religious nor secular, for the consistent fabric of Indian life was never rent by the western dichotomy of religious belief and worldly practice."

Most art historians today acknowledge the inseparability of sacred and worldly fields of culture and have embraced their interconnections or turned to other ways of framing studies of South Asian art. Hindu temple sculptures, for example, are explored not only through religious texts and iconography but also through the lenses of patronage and reception. Scholars have brought to light South Asian ways of understanding how sacred life intersects with the mundane. Some literary scholars find useful frameworks in the Sanskrit terms *laukika* and *alaukika*, sometimes translated as "worldly" and "otherworldly," respectively. This pair of terms identifies things that are more and less ordinary and is sometimes used in relation to works of art, but it is nevertheless very different from the sacred/secular duality.

The works of South Asian art in this chapter embody a wide range of ways that the "ordinary" world—most often the arena of politics and kingship but sometimes that of family or romantic life—intersects and interacts with the world of religion and divinity. They also present diverse depictions of sacred figures, the meanings and making of which can rarely be explained only by reference to religion. The artworks reflect the great variety and complexity of indigenous concepts of the divine and the earthly, and their relationship with each other.

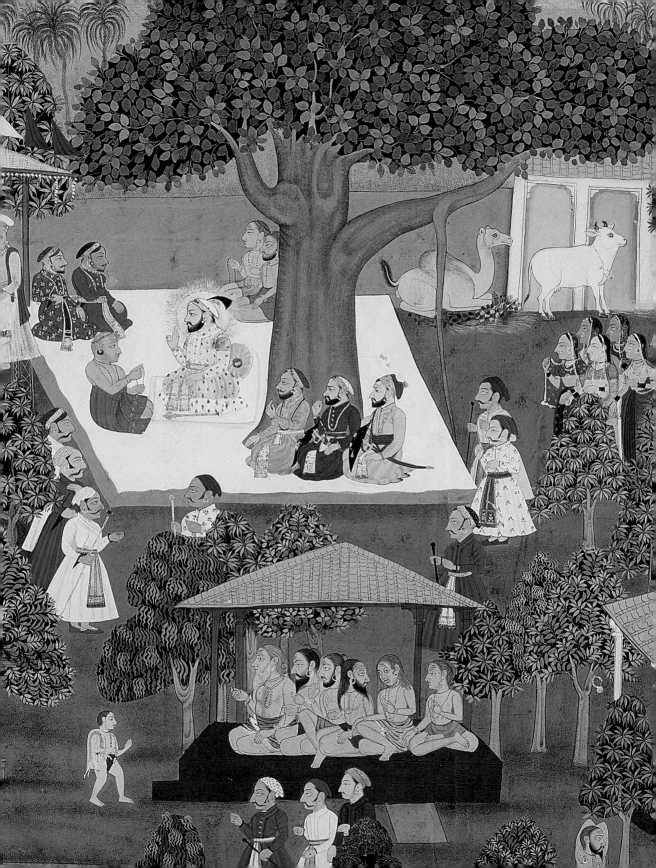

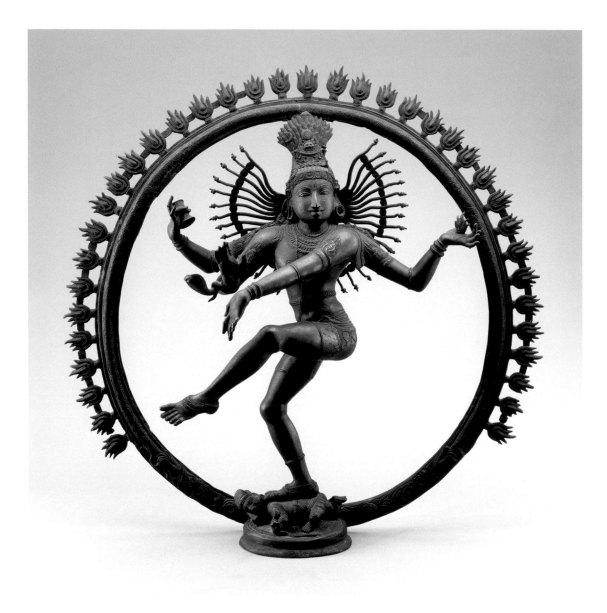

Shiva as Nataraja (Lord of the Dance)

about 1800

Tamil Nadu, India

Nataraja, the form of the Hindu god Shiva as Lord of the Dance, is a quintessentially sacred figure associated with the southern Indian town and temple of Chidambaram, considered an important sacred site since at least the seventh century CE. A large temple there contains, even today, a bronze image of Nataraja in its inner sanctum. This and other Nataraja images are strongly associated with Shiva's role as destroyer of the universe. With his left foot raised and his arms spread wide, hair flung out on either side of his head, he is in the midst of the *ananda tandava*, the "dance of furious bliss" that brings the world to an end, readying it to be created again.

Sculptures like this one may have been used as early as the tenth century as objects of worship. Through rituals performed within and outside the temple, the god would be invited to inhabit the sculpture and be worshipped. Though clearly religious in nature, these practices point to the overlapping zone between the sacred space of the divinity and the world outside the temple. A sculpture like this one is treated, quite literally, in a manner befitting a king. Priests carry out a range of rituals designed in imitation of the treatment given to a worldly ruler: the god is to be bathed, dressed, fed, entertained, and even put to sleep at the end of the day—actions conveying deep respect and care. In the medieval period, rulers in southern India took responsibility for providing funds for these ministrations. This mutual interdependence of temporal and spiritual power is a prominent feature of South Asian societies dating back to the very earliest Sanskrit texts, known as the Vedas (about 1500 BCE–1200 BCE).

Copper

103 x 102 x 33 cm (40½ x 40⅛ x 13 in.)

Marianne Brimmer Fund 21.1828

Darbar of Jahangir, about 1624
Attributed to Manohar (active about 1582–1624,
Indian) and Abu'l Hasan (active about 1600–1630,
Indian)
Delhi area, India

At first glance, this painting seems to be a quintes-
sentially "secular" image. It depicts the emperor Jah-
angir, who ruled over the Mughal empire from 1605 to
1627, seated on a dais, with attendants and his sons
surrounding him. Below these high-ranking figures
are a wide range of individuals who may have come

to the emperor's _darbar_ (audience) in order to offer
a gift, request assistance with a problem, deliver a
message, or for any number of other reasons. Most
of the sixty-eight courtiers and petitioners pictured
in the lower two-thirds of the painting are identified
by tiny Persian inscriptions, often written on their
turbans or robes. The Mughals had a penchant for
documentation and this painting may, in fact, be a
depiction of everyone who was present at the _darbar_
on a certain significant day.

Even though the painting was intended as a
record of a specific event, time, and place, religious
imagery pervades it as well. The Mughal _darbar_ func-
tioned almost as a kind of shrine within which the
emperor was made visible to his subjects the way a
god in a temple is made visible to devotees. Jahangir
adhered to the belief that he—like his father, the
emperor Akbar—was the recipient of divine light
emanating from God. This notion of divine kingship
was drawn in part from Islamic thought, in which
rulers are sometimes described as "the shadow of
God," but it also resonated with earlier South Asian
beliefs in sacred sovereignty. One reflection of this
is that Jahangir was nearly always depicted with a
halo by his artists, as he is here. Another sign is the
figure of the Virgin Mary, who appears above and just
behind the ruler. European and Christian imagery
was of great interest to the Mughals for its exotic
nature, but as Mary plays an important role in the
Qur'an, her appearance here may also have enhanced
Jahangir's aura of combined secular royalty and
sacred divinity.

Ink, color, gold, and silver on paper
35 x 20 cm (13¾ x 7⅞ in.)
Bartlett Collection—Museum purchase with funds from the
Francis Bartlett Donation of 1912 and Picture Fund 14.654

Mandala of Hevajra, 15th or 16th century
Probably Tibet

Though it looks utterly different, this image is
related in several ways to the painting of the
darbar of Jahangir. Both works depict a power-
ful figure in his palace, surrounded by com-
panions of many kinds. Though crowded, the
compositions are designed to direct our eyes to
the key figure, the sight of whom is understood
as spiritually beneficial.

Hevajra, a divinity who is the personifica-
tion of a Tibetan Buddhist *tantra* (spiritual
discipline), appears in this painting with his
consort, Nairatmya, inside a celestial palace,
seen from above and formed of concentric
circles and squares. Outside the palace is the
sacred universe of Hevajra, which includes
other deities and eight great cemeteries—rep-
resentations of what humans must overcome
to attain enlightenment. The cemeteries
appear in a ring around the palace and contain
images of wild animals, *chaitya*s, teachers
(*siddha*s), fires, and wrathful deities. An offici-
ating monk in the lower left corner sits next to
platforms bearing ritual offerings for Hevajra.

A work like this would have been used by
Tibetan Buddhists as a tool for visualization.
Devotees would first construct the palace within
their minds, then mentally go into the palace
to pay homage to Hevajra. Through this act, the
devotees would earn merit and wisdom about the
nature of reality.

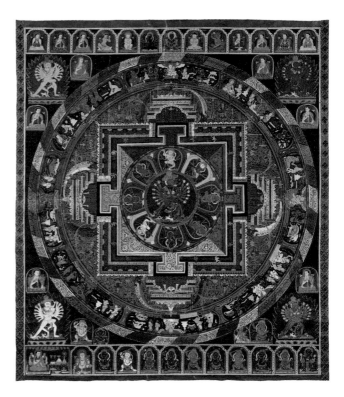

Distemper on cotton
62.2 x 55.8 cm (24½ x 22 in.)
Gift of John Goelet 67.823

Two Sa-skya-pa patriarchs, early to mid-15th century
Tibet

This hanging scroll painting depicts two revered Tibetan Buddhist teachers seated on elaborate thrones and surrounded by divinities and important monks. The position of their bodies and hands and the direction of their gazes reveal much about what is happening in the painting. The two main figures turn toward each other, hands in teaching position, indicating that they are revered teachers who were closely connected to one another. In fact, they were brothers. Sonam Tsemo (1142–1182) and Dragpa Gyaltsen (1147–1216) were members of the Sa-skya-pa tradition of Tibetan Buddhism. They served as abbots of the Ngor Monastery in central Tibet.

Although there are divine beings in this and many other works of Buddhist art, the central figures of Buddhism are teachers rather than gods. Teachers are treated with immense reverence and are emulated, not worshipped. They pass on the teaching of the Buddha, helping followers to shape their lives so that they may one day pass beyond the world of suffering and illusion, achieving liberation.

This painting is the seventh in a set of *thangka*s (hanging scrolls with textile borders) that were commissioned as part of the funerary services for a Buddhist teacher who died in 1419. It depicts and celebrates the continual transmission of Buddhist knowledge from teacher to student.

Distemper on cotton
84 x 78.2 cm (33⅛ x 30¾ in.)
Gift of John Goelet 67.831

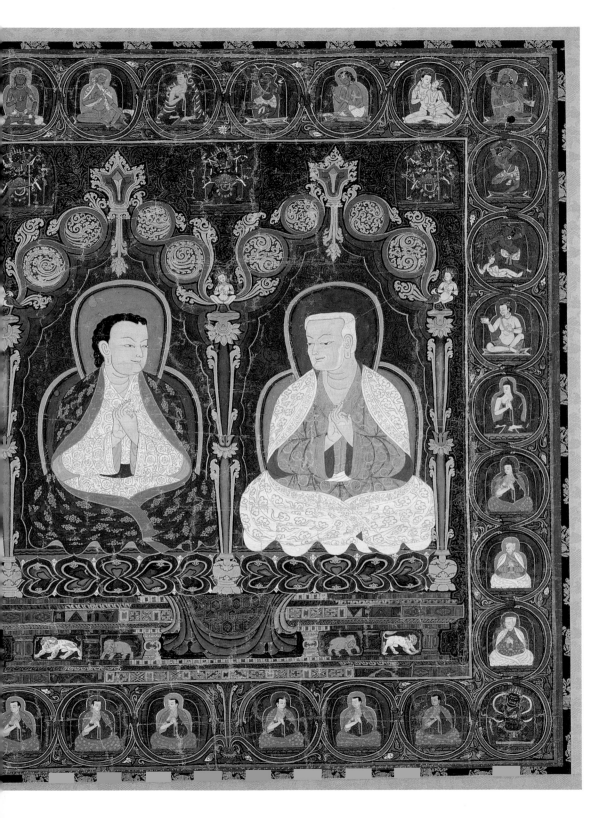

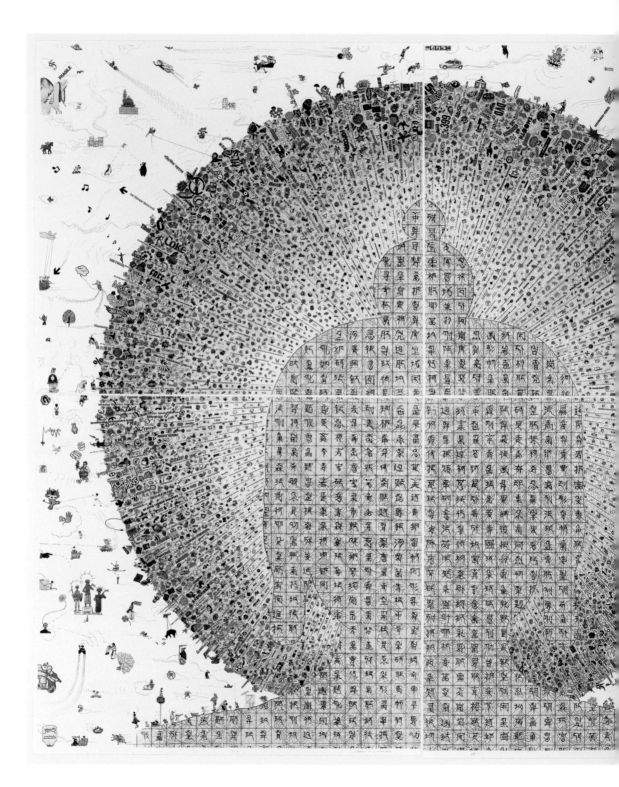

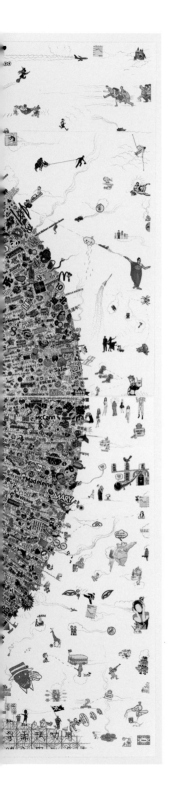

The Shambala in Modern Times, 2008
Gonkar Gyatso (born in 1961, Tibetan)

Look closely at this image of the head of the Buddha and you will notice that his halo is made up of product logos, cartoon figures, 50-percent-off labels, and innumerable other representations of twenty-first-century consumer culture. The presence of these icons of materialism within the Buddha's image is a reminder that the world contains both beauty and ugliness, transcendence and attachment, distraction and peace. Usually Shambala—a mythical land of universal peace, health, and wisdom, according to Tibetan Buddhism—is envisioned as a mountain paradise. Artist Gonkar Gyatso's modern version is somewhat less transcendent.

Gyatso's meticulous positioning of each sticker within this work is suggestive of the systematic composition of symbolic images in Tibet's *thangka* painting tradition, which Gyatso studied during time spent in India. This artistic inheritance is also evident within the head and shoulders of the Buddha, where a grid filled with Tibetan and Chinese characters is overlaid on drawings of leafy scrolls and symbols, traditional motifs of *thangka* painting.

The Shambala in Modern Times guides viewers through a process of awakening: attention is drawn away from the chaotic melee of worldliness to the peaceful image of the Buddha and thus to inner awareness and serenity.

Giclée print with gold and silver leaf on paper
192 x 212 cm (75⅝ x 83½ in.)
Marshall H. Gould Fund 2010.755

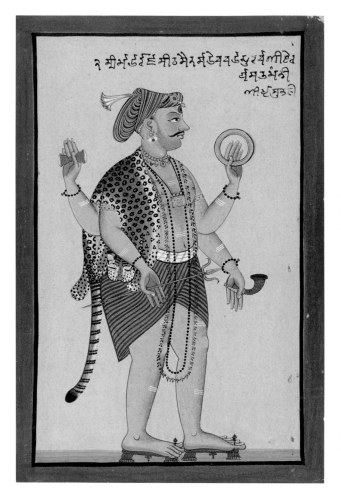

Raja Sidh Sen of Mandi as Shiva

about 1725

Mandi, Punjab Hills, India

The pictorial details of this painting suggest a representation of the Hindu god Shiva. The main figure bears all the attributes of the god: four arms and hands in which he holds a drum, trident, discus, and horn; ashen skin; a jaguar pelt around his shoulders; and *rudraksha* prayer beads hanging from his neck. However, an inscription in the upper right tells us that the figure is Sidh Sen, the raja, or king, of the small kingdom of Mandi from 1684 to 1727. Indeed, the way the figure is depicted—in profile, standing against a blue background—is typical of portraits of elites and rulers in eighteenth-century South Asia.

Sidh Sen's strength was legendary. It is said that he was so strong he could remove the face from a coin merely by squeezing it between his fingers. In part because of his powerful physique, Sidh Sen was apparently believed by his subjects to be an earthly manifestation of Shiva. This portrait seems to have been made when Sidh Sen was already an old man, but it shows the ruler as he perhaps wanted to be seen at the height of his reign: a semidivine figure who combined the powers of a god with the authority of a king.

Opaque watercolor and gold on paper
27.1 x 18.2 cm (10⅝ x 7⅛ in.)
Keith McLeod Fund 2001.137

Maharana Sangram Singh of Mewar visiting Savina Khera Math, about 1720–30
Mewar, Rajasthan, India

Like the unusual royal portrait of Raja Sidh Sen, this painting offers an image of a ruler in whose domain divine and earthly matters meld into one. The painting shows the Savina Khera *math*, a Hindu monastery constructed in the early eighteenth century in the Rajput kingdom of Mewar. It was customary for the ruler of Mewar to allocate money for the upkeep of the *math* and to show the holy men there great respect; in exchange, they regularly appeared at the Mewar court to perform important rituals.

The reciprocal relationship between kings and their spiritual guides is borne out by the imagery of the painting. Maharana Sangram Singh, who ruled Mewar from 1710 to 1734, is depicted twice, both times with a golden halo and an entourage of attendants and courtiers; his jewelry and clothing are further evidence of his stature in the world of earthly power. Yet Sangram Singh is also present as a pious devotee: in the upper left, he is pictured weighing the Gosain Nilakanth, an abbot of the monastery, on a balance so that the holy man can be presented with his weight in gold. He appears again in the upper center of the painting by a large tree, seated on a platform in conversation with the yogi Bhikarinath.

Opaque watercolor and gold on paper, backed with cotton mesh
65.1 x 73 cm (25⅝ x 28¾ in.)
Charles Bain Hoyt Fund 1999.94

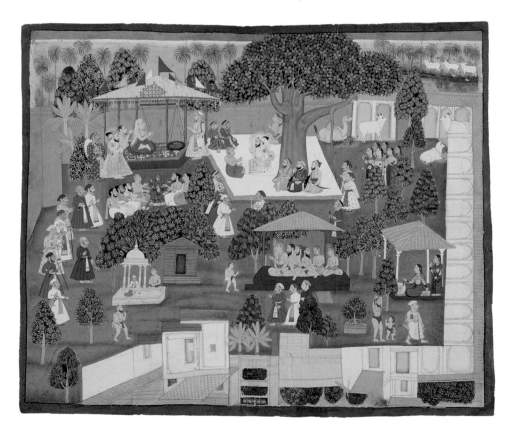

Shiva as Vinadhara, late 10th or early 11th century
Tamil Nadu, India

Music and dance—primarily seen as secular modes of expression or entertainment in the West—in South Asian art are often associated with divinities. This is particularly so in works related to Hinduism, where it is not uncommon to see, as in this beautiful bronze made during the height of the Chola period, a representation of a Hindu god in the midst of a dance or playing music. Dance takes many meanings and forms in South Asian art, but in nearly all cases it represents the potential to transform the world or the self.

While the musical instrument he once played is now gone, it is clear that this figure of Shiva once held a *vina* (a lute-like instrument). His lower left hand held the *vina*'s neck while the lower right plucked its strings. The sense that music is being played is amplified by the figure's pose: Shiva's body bends at the hip, allowing him to bear the weight of the instrument while also conveying that he is swaying gently to the music as he plays.

Chola bronzes are particularly valued for the supple beauty and naturalism of their bodies. This figure's lean but strong thighs and body-hugging garments evoke the quality of a human body even while its four arms remind us that he is superhuman.

Bronze
61 x 33 cm (24 x 13 in.)
Denman Waldo Ross Collection 31.390

Bhairava Raga, about 1640–50
Orchha, Madhya Pradesh, India

A couple sit on a bed, looking into each other's
eyes and holding large lotus blossoms. They are
inside a palace, attended by women holding fly
whisks and musical instruments. The arched
doorways and domed pavilions recall the archi-
tecture of the region of central India in which
this painting was made. One might reason that
the image depicts a private moment between a
king and queen; the blue skin of the male, how-
ever, suggests that he is the Hindu god Krishna,
strongly associated with love.

Romantic moments such as this are the most
common subject of *Ragamala* paintings: sets
of paintings associated with modes (*raga*s and
*ragini*s) of Indian classical music. Such sets were
made for cultivated patrons with a taste for art,
music, and literature. The amorous imagery in
this example, which is associated with the musi-
cal mode called *Bhairava*, is underscored by the
poetic lines written on the reverse that describe
the acts of wild abandon carried out by Kama-
deva, "god of love." With the insertion of the god,
this intense earthly passion becomes a meta-
phor for the spiritual experience of casting off
moral restraints and finding liberation through
total surrender to God.

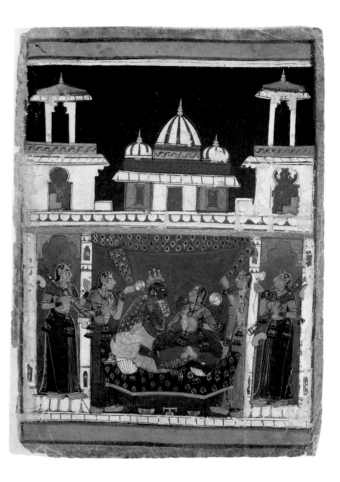

Opaque watercolor on paper
19.5 x 14.5 cm (7⅝ x 5¾ in.)
Ross-Coomaraswamy Collection 17.2371

Two lovers, 13th century
Odisha, India

The subject matter of this small sculpture, among the finest ivories known from eastern India, is a *mithuna*. The Sanskrit word means "couple," as well as "the act of coupling" in a sexual and also a metaphorical sense. It dates back to the era of Vedic rites, in which the ritual joining of pairs was a prominent feature. In reference to art, *mithuna* is often translated as "loving couple" and refers to a depiction of two figures in a pose that is romantic, affectionate, or erotic. In many cases, the pair is clearly divine: a god with his consort. Shiva and Parvati, or Vishnu and Lakshmi, for example, appear on the walls of Hindu temples or as portable bronzes for worship.

At other times, a *mithuna* is not explicitly divine but rather represents two human beings romantically posed, sometimes in an erotic embrace. Embracing couples are often depicted at the entrance to Buddhist or Hindu shrines, where they provide protection and prosperity in a manner similar to that of the *yakshi* in this chapter. In South Asia, things can be sacred without being specifically involved with a god or God. This was particularly so in ancient and medieval Orissa, where erotic coupling is seen on a remarkable number of Hindu temples. Couples also appear on

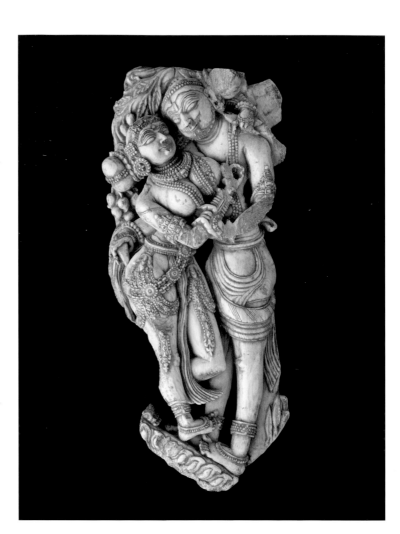

luxury items that have little explicit connection to sacred spaces or figures, as in this small sculpture. Like the *mithuna*s on Hindu temples, this one would have lent auspiciousness to the environment in which it was viewed.

Ivory
15.9 x 7.6 cm (6¼ x 3 in.)
Keith McLeod Fund 1987.622

**Ravana with his ministers; Sita in the
Asoka grove**, about 1725
Attributed to Manaku (about 1700–1760, Indian)
Page from the *Siege of Lanka* series
Guler, Punjab Hills, India

The *Ramayana*, one of South Asia's great works
of literature, dating to about the middle of the
first millennium BCE, is a lengthy Sanskrit epic
about a hero named Rama; Rama's wife, Sita; and
Sita's capture by the demon Ravana. Although
the *Ramayana* probably originated in a local tale
about the kings of Kosala, an ancient kingdom
in modern Uttar Pradesh, the story evolved
into an epic that plays out upon a much larger
stage. Throughout the text, gods move into, out
of, and through the world of earthly beings on
a regular basis. Rama is, in fact, an incarnation
of the god Vishnu, and Sita is an incarnation of
the goddess Lakshmi.

This is a page from a series of unusually
large illustrations known as the *Siege of Lanka*,
produced in a workshop under the guidance of
the artist Manaku. All of the surviving pages
of the series portray scenes from a chapter of
the *Ramayana* that deals with Rama's attempt
to free Sita from her imprisonment within
Ravana's island fortress. On the left, the many-
headed Ravana sits like a king in his palace
with his ministers, while on the right Sita rests
under a tree in a garden, guarded by a colorful
assembly of female demons.

By the time this series of paintings was made,
Rama was understood in South Asia both as an
avatar of Vishnu and as a model of the ideal king.
As early as the fourteenth century, rulers across
the subcontinent had begun to emulate and liken
themselves to Rama in various ways. This may have
been in response to tumultuous historical events,
such as the arrival of Turkic peoples from Western
and Central Asia and the establishment of the Delhi
Sultanate (1206–1526) in what is now northern India.
Rulers may have turned to the *Ramayana* as a way to
affirm and legitimate their rule, as well as to suggest
that ordinary life in their kingdom was being blessed
and watched over by the gods.

Opaque watercolor and gold on paper
59.7 x 83 cm (23½ x 32⅝ in.)
Ross-Coomaraswamy Collection 17.2748

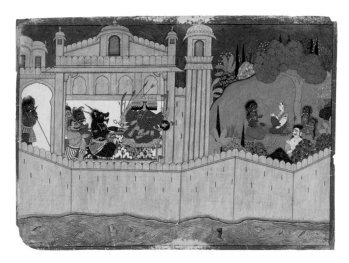

Nature goddess (*yakshi*), 25 BCE–25 CE
Sanchi, Madhya Pradesh, India

This fragment of a sculpture of a nature goddess, or *yakshi*, is from the western or southern gateway at the important early Buddhist site of Sanchi. Four gateways punctuate the railing around the central stupa (reliquary mound), and upon each appear multiple sculpted *yakshi*s. In ancient sacred Hindu and Buddhist sites of South Asia, entry points were considered sites of vulnerability, and auspicious symbols were needed as protection and to endow the site with prosperity. In South Asia, many of the most powerful symbols of good fortune and plenty are drawn from nature. Animals, such as the goose, and plants, such as the lotus, appear frequently, but undoubtedly the most important and potent symbol is that of a female figure whose body is highly exposed though not nude.

This goddess wears a beaded girdle and sash, and a necklace with a large pendant. Her hair is plaited and a flower garland hangs down her back. Her full figure and the unabashed emphasis on her vulva signify her fertility. In contrast to the Western tendency to exclude sexuality from the sacred sphere, it is her very sexuality that makes this goddess a symbol of health and abundance. When intact, she stood beside a tree with one arm reaching up to hold its branches and a foot touching its trunk, an image rooted in an ancient South Asian trope of beautiful young women making a tree flower and bear fruit.

Elaborate stupa railings like that at Sanchi were not, as they may seem at first, boundaries that divided the secular world from the sacred. Instead, they separated space for public ritual from that for individual worship. The outer boundary of such sites, where they met with what might be considered the world of daily life, was not particularly emphasized but was often marked with a lower and less elaborate wall.

Sandstone
72.1 x 35.6 x 22.9 cm (28³/₈ x 14 x 9 in.)
Denman Waldo Ross Collection 29.999

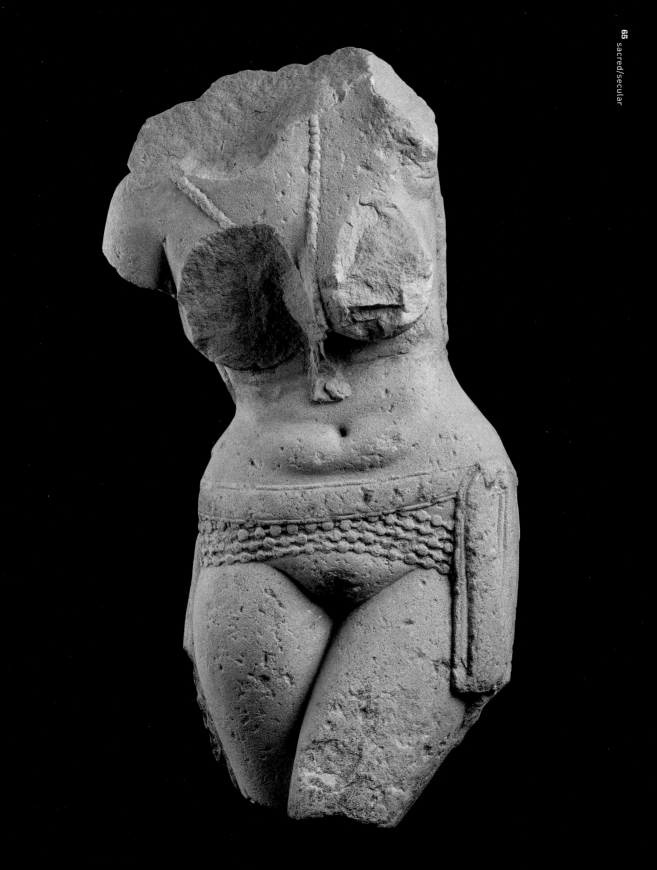

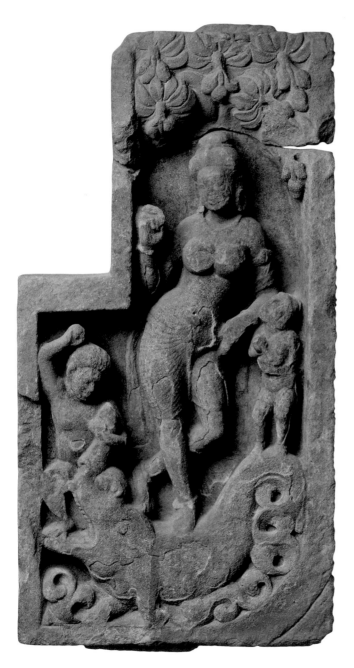

Ganga, about 405–15 CE
Besnagar, Madhya Pradesh, India

Like the *yakshi*, the woman who stands under a heavily laden mango tree in this sculpture from a Hindu temple is more than a human being. She is the goddess Ganga, an anthropomorphic representation of the Ganges River, which flows across and has long nourished northern India. Here Ganga stands upon a mythical water creature: a *makara* with its crocodile-like jaws wide open. She is accompanied by two *gana*s (dwarves), one of whom she leans on while the other extracts pearls from the mouth of the *makara*.

This sculpture was once part of a doorjamb at the entrance to the sanctum of a Hindu temple, and would have appeared opposite a similar sculpture representing the Yamuna River. These sacred river images fall within a broad array of natural and geographic imagery—including lotus flowers, mountain-like motifs, and a range of nature spirits—that are required ornamentation for Hindu temples.

The Ganges is believed to have originated in heaven and descended to earth. It is thus a link between earthly and heavenly realms. It is also considered to be purifying. At the doorway to a shrine, therefore, the image would have cleansed those who entered and prepared them for the powerful presence of the god beyond.

Sandstone
73.5 x 38.1 x 12.7 cm (28⅞ x 15 x 5 in.)
Charles Amos Cummings Bequest Fund 26.26

Jina Rishabhanatha, early 11th century
Probably Gujarat, India

Though the figure in this bronze sculpture perches king-like on an impressive two-level throne, he represents neither a king nor a god, but rather the Jina (Jain spiritual teacher) Rishabhanatha. The figure is marked as different from an ordinary human being by his elongated earlobes and the mark on his chest, although he is not divine. Adherents of Jainism revere human beings like Rishabhanatha who have purified their souls to the extent that they are able to achieve complete enlightenment and release from the world. The souls of these Jinas then ascend to the top of the universe, where they stay for all eternity in a state of complete inaction but possessed of infinite perception, knowledge, capability, and bliss.

This sculpture was probably commissioned by a layperson and donated to a Jain temple. A donor figure kneels on the lower level at the left. Above this, small figures of lions and elephants support the Jina's throne, flanked by two minor Jain divinities, Ambika and Sarvanubhuti.

Bronze with copper and silver inlay
24.3 x 28.5 x 13.7 cm (9⅝ x 11¼ x 5⅜ in.)
Marshall H. Gould Fund 62.928

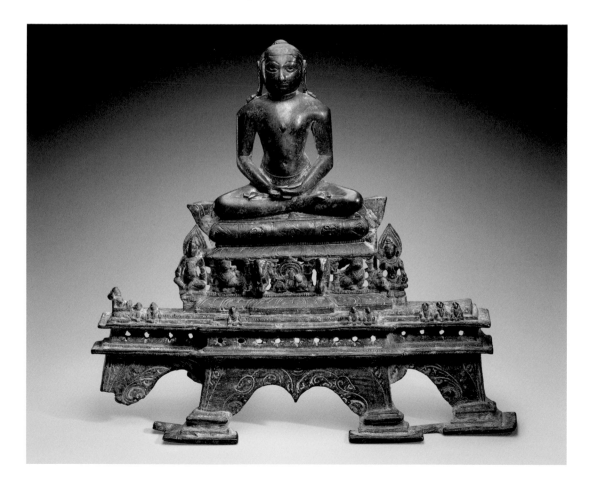

Standing Buddha, 7th century CE
Andhra Pradesh, India

This slender Buddha has calm, smil-
ing features and strong shoulders. He
stands with his left hand raised and
holding the gathered end of his robe,
which exposes his right shoulder
and clings to his body with almost
no folds. Teacher, preacher, monk:
these are the humble guises in which
this sculpture presents the Buddha.
Although the *ushnisha* (protrusion
at the top of his head), elongated
earlobes, and curl of hair between his
eyes mark him as something other
than an ordinary human being, his
unadorned and exposed body seems to
convey the Buddha's essential human-
ity. He is sacred, though not a god.

Followers of Buddhism, even as
early as the seventh century CE, when
this sculpture was created, strove not
to reach a god beyond the boundaries
of the human world but to shape their
lives in the world as a way to improve
the self and eventually to escape from
the cycle of birth and rebirth. Central
to the Buddha's teaching was *dhamma*
or *dharma*, a social ethic of family
and community based around nonvio-
lence, tolerance, and respect. Without
living in accordance with this ethic,
one could not achieve liberation from
rebirth.

Copper
50.3 x 12.7 x 10.2 cm (19¾ x 5 x 4 in.)
Gift of the Government Museum, Madras 21.1504

Palace Façade, 2005

Rajaram Sharma (born in 1963, Indian)

Artists in the kingdom of Mewar in Rajasthan between the seventeenth and nineteenth centuries painted many images of Mewar's rulers in and around their palaces. Rows of arched windows and decorated courtyards frame scenes of audiences, dancing, feasting, and processions. Here, in artist Rajaram Sharma's contemporary take on these older images, we see the royal palace in Udaipur stripped of all pomp and circumstance: the palace alone fills the frame. Whether the scene is peacefully empty or eerily abandoned is up to the viewer.

Mewar's rulers, who belonged to the Sisodia dynasty, which came to power in the fourteenth century and lost its territory in the sixteenth century, traced their lineage back to the sun itself. They adopted a solar symbol as their royal insignia and decorated the Udaipur palace with a large solar disk, depicted here just left of the center of the painting. The goal of this elevated genealogy was not only to give the dynasty an aura of divinity but also to convey that the Sisodias' high status within Rajasthan was both age-old and permanent.

Opaque watercolor on paper

16.2 x 21.9 cm (6⅜ x 8⅝ in.)

Charles Bain Hoyt Fund 2010.36

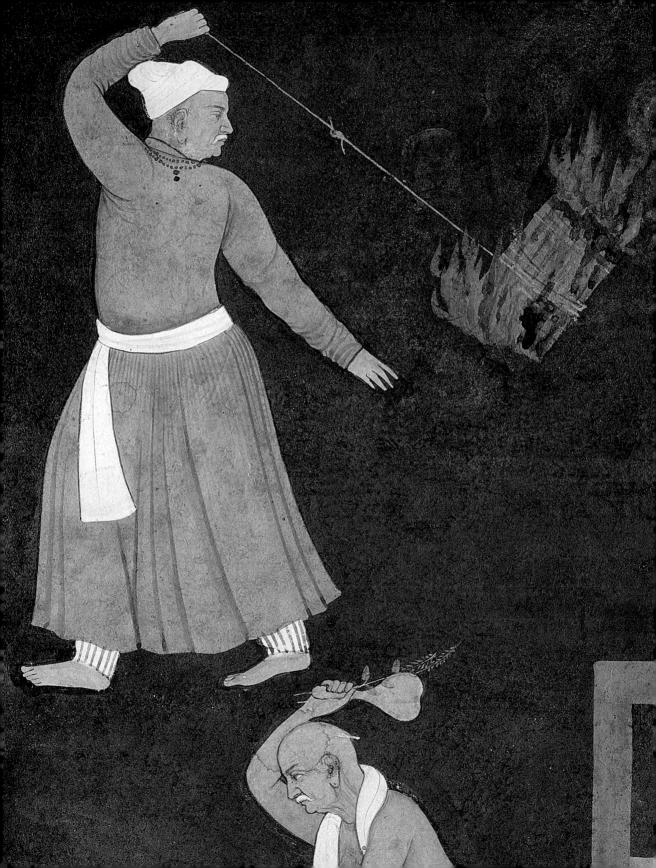

Hindu/Muslim

The vast landmass of South Asia is home to an enormous range of religious practices and beliefs. The largest groups are Hindus (about 60 percent) and Muslims (about 30 percent). South Asian religion is sometimes oversimplified into a single opposition between these two groups, but there are, and have always been, many other thriving faiths.

Little is known about the religious beliefs or practices of the Indus Valley Civilization (2600 BCE–1700 BCE), as the Indus Valley script is as yet undeciphered and no religious objects or buildings can as yet be securely identified. More is known of the Vedic period (1500 BCE–about 500 BCE), from which survive a series of texts in an ancient form of Sanskrit known as the Vedas. The Vedas consist of hymns, charms, spells, and ritual observations that were current among the Aryans (from the Sanskrit *arya*, meaning "noble"), an Indo-European–speaking people who lived in what is now northern India. Over time, what was Vedic religion shifted into what is today called Brahmanism. Brahmans, as followers of the religion were called, were members of a priestly class who served as intermediaries between the gods and other human beings during rituals they alone could carry out. Despite the prominence of Brahmanism in this period, localized beliefs and practices were also in place all over South Asia, often centered on the worship of local natural features such as streams and mountains.

When Buddhism and Jainism emerged, around the sixth century BCE, it was in many ways a response to Brahmanism. Both new belief systems asserted that a priest was not needed for an individual to achieve a higher spiritual state. Instead, one simply needed to follow the teachings of an ascetic such as Siddhartha Gautama (Buddha) or Mahavira (the final Jain spiritual teacher) to achieve enlightenment and release from the cycle of birth and rebirth. While followers of Buddha and Mahavira sought to find release through the practices they espoused, Brahmanism gradually underwent changes around the second and first centuries BCE, and its new form emphasized worship of particular gods, only some of whom had before been important. Sects emerged, focusing worship

upon Vishnu, Shiva, and various forms of a great goddess. These developments set the stage for what is known today as Hinduism, which evolved greatly over the first two millennia CE and even to this day continues to change. The word *Hinduism* comes from the Persian name for the people who lived beyond the Indus River and was not used by South Asians to refer to their religious identity until Europeans began to use it that way in the eighteenth century.

Judaism, Christianity, and Islam each have a long history in South Asia. Judaism and Christianity both arrived in the region in ancient times, and the first Muslims arrived there during the seventh century CE, possibly even during the lifetime of Islam's prophet, Muhammad. Around this time, the number of followers of Buddhism in South Asia may have begun to fall, but it was also in this period that Tibetan Buddhism emerged in the far northern part of the region, and that tradition thrives there even today. Among the later religions to emerge in South Asia, perhaps the most prominent is Sikhism, a monotheistic faith first established in the fifteenth century in the Punjab region. Sikhs follow the teachings of ten earthly gurus and a sacred text called the *Guru Granth Sahib*.

Until the period of European colonialism and the advent of the census and its requirement that people identify themselves with a single faith, the notion that one could follow only one religion at a time was not dominant in South Asia. Religious identities were fluid and permeable, co-existing (if not always harmoniously) within the shared religious space of premodern South Asia. Over the last few centuries, however, colonial and modern nationalist politics have led many, both within South Asia and outside it, to view the region's religious sphere reductively as a space in which Hindus and Muslims are locked in a violent and never-ending battle. The two religions are all too often cast as irreconcilable worldviews, eternally and essentially opposed.

The arts of South Asia offer a different, and much more complex, picture of religion in South Asia, revealing that religious identities were not always as fixed as they seem to be today. Many objects combine ancient Indian motifs and techniques with others that have a long history in Islamic societies, demonstrating that over extended periods Hindu and Muslim communities (which are themselves almost infinitely varied) intermingled and evolved in tandem. At certain historical moments, particular groups have cultivated and expressed an "us" and "them" relationship between Hindu and Muslim communities; Mughal illustrations of Sanskrit literature, almost certainly motivated by curiosity about the unfamiliar tales of Hindu mythology, may reflect this sense of separateness. And yet while there are substantial differences in their religious beliefs and practices, Hindu/Muslim is by no means a fundamental dichotomy within South

Asian culture. The areas of overlap and interconnection between the two religions are extensive and run deep.

Artworks from South Asia also stand as evidence of the many other major religions that have either emerged in the region or been adopted there, further exploding the Hindu/Muslim binary. Though today there are relatively few Buddhists in South Asia, the size and impact of Buddhist communities on the culture of the region is colossal. Art objects made by and for Christians and Jains further reflect the rich plurality of South Asia's religious sphere. Art has been produced by many communities and faiths throughout the region's history.

Man carrying out Diwali rituals, about 1740
Attributed to Nainsukh (about 1710–1778, Indian)
Guler or Jasrota, Punjab Hills, India

This painting features three images of a man carrying out a series of intricate rituals associated
with Diwali, the Hindu festival of light. On the right,
he sits before a house, dripping water onto a vessel before trays of lit lamps. In the bottom left, the
same man swings a gourd over his head. Finally, in
the upper left, he whirls around, holding a bundle
of flaming twigs. The four lines of Sanskrit on the
reverse reveal that these are depictions of rituals
described in the *Shatapatha Brahmana*, an ancient
text that describes Vedic rituals, history, and mythology. According to that text and to later Hindu ritual
manuals, on a certain night during Diwali, these rituals should be performed to ward off death, witchery,
and evil dreams, and to cleanse oneself of sin.

The rituals depicted here are ancient, but the style
of the painting places it firmly in the eighteenth century, when the artist Nainsukh made closely observed
portraits like these. The facial features of the priest
are precisely rendered, as are his clothes and the
position of his body during each ritual. One fine
detail, for example, is the little tuft of *shikha*-hair at
the base of his otherwise shaven skull, visible in the
bottom left vignette, a detail confirming his identity
as a Brahman.

Opaque watercolor on paper
20.5 x 27.2 cm (8⅛ x 10¾ in.)
Ross-Coomaraswamy Collection 17.2622

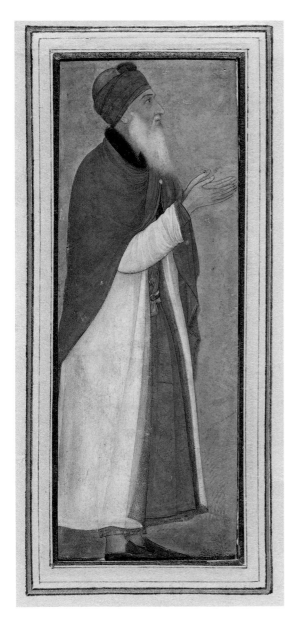

Portrait of a Muslim holy man, about 1620
Attributed to Abu'l Hasan (active 1600–1630, Indian)
Northern India

In this fragment of a painting, an elderly man stands
with hands held together in a prayerful position. In
addition to this pose, the man's layered garments,
turban, and long white beard identify him as a Mus-
lim holy man. Such figures appear often in paintings
made for Muslim rulers and courtiers in the early-
seventeenth-century Mughal empire, where they are
sometimes depicted presenting a holy book. Although
there is no environment around this figure other than
a tiny hint of grass at his feet, he was likely intended
to be seen as a figure of great learning in fields such
as Islamic scripture and law.

The painter Abu'l Hasan, who worked in the impe-
rial Mughal atelier during the time of Emperor Jah-
angir (r. 1605–27), is known for his sympathetically
rendered and carefully observed portraits. This small
image shows the artist at his best, making visible the
sincerity and depth of the holy man's dedication.

Opaque watercolor and gold on paper
10.4 x 4.9 cm (4⅛ x 1⅞ in.)
Bartlett Collection—Museum purchase with funds from the
Francis Bartlett Donation of 1912 and Picture Fund 14.653

Ganesha, early 11th century
Eastern Rajasthan, India

Although the Hindu god Ganesha is certainly South Asia's most recognizable and popular elephant, elephants are important emblems within many South Asian cultures and belief systems. They are symbols of strength and wisdom in Hinduism and Buddhism, and appear on temples, stupas, and monasteries. As the noblest of mounts, they are featured in paintings of court processions and battles. They can also be omens of royal birth, as when the future birth of the Jain teacher Mahavira was revealed to his mother through a dream of a white elephant.

This image, made for the extensively sculpted exterior of a Hindu temple, shows Ganesha as the part-elephant, part-man that Hindu myth describes. He was a normal-bodied child of Shiva before the god accidentally cut off his son's head and had to replace it with the head of the closest being at hand: an elephant. Here we see, first and foremost, Ganesha's curling trunk, massive belly, and the thick thighs that support his wives. The artist has cleverly created open space around the god's rotund torso, counterbalancing his heft. The contrast between linear surface decoration and rounded forms makes this a particularly lively depiction of Ganesha, a widely beloved god who is an emblem of good fortune and a "remover of obstacles."

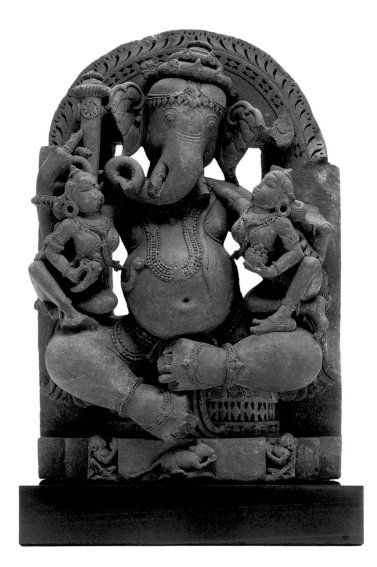

Sandstone
105.1 x 68.6 x 33 cm (41⅜ x 27 x 13 in.)
John H. and Ernestine A. Payne Fund, Helen S. Coolidge Fund, Asiatic Curator's Fund, John Ware Willard Fund, and Marshall H. Gould Fund 1989.312

Ewer in the shape of a goose, 15th or 16th century
Deccan region, India

The body of this ewer takes the form of a goose (*hamsa*), another common motif in ancient Hindu and Buddhist iconography, where it is associated both with the waters of life, because of its aquatic nature, and with wisdom and purity, on account of its legendary ability to separate milk from water. The spout takes the form of a *makara*—a mythological aquatic creature that resembles a crocodile with an elephant's trunk and a fish's tail—another quintessentially South Asian motif and one of the most commonly used propitious emblems in Indian decorative art.

Other features of the ewer resonate more closely with Islamic artistic traditions, which came to South Asia with travelers and traders soon after the emergence of Islam itself in the seventh century CE. Thus, while vessels in the form of animals are quite rare in Indian metal-work before the Sultanate period (1206–1526), when Muslim-ruled kingdoms first controlled large portions of South Asia, zoomorphic ewers have a long history in Islamic metalwork going back to the eighth century CE. The *hamsa* ewer beauti-fully represents a confluence of motifs, mythologies, and objects that belong solely to neither Islamic nor Hindu cultural traditions. Indeed, it would have served equally well the needs of either a Muslim or a Hindu owner, facilitating the performance of ritual ablutions before religious observances within the home; or it may have been proffered by a servant at an elite banquet, enabling Muslim and Hindu guests alike to cleanse their hands before and after the meal.

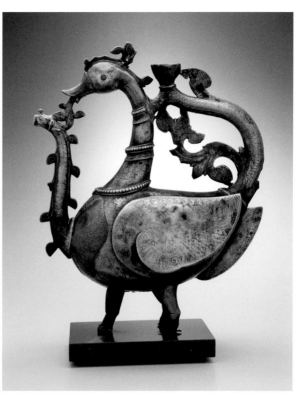

Bronze with layer brass repairs, copper-arsenic paste
Height: 38.5 cm (15⅛ in.)
Helen and Alice Colburn Fund 37.470

Pathology of Suspension #6, 2005
Shahzia Sikander (born in 1969, Pakistani)

Iconic forms from Hindu art appear transformed in this work by Shahzia Sikander. Sikander, beginning in the 1990s, pioneered the reinvigorating of the "miniature" painting tradition in order to invest it with contemporary meaning and critical power. This type of painting, which flourished in Rajput and Mughal workshops during the sixteenth through nineteenth centuries, was seen throughout much of the twentieth century as too rooted in the past to offer a viable way to bring South Asian art into the present.

In this neglected genre, Sikander found a way to critique imperial and colonial modes of representation. Having mastered the traditional technique and format, she began almost systematically to deconstruct and manipulate its elements and forms. In this painting, a confluence of marks at the center of the page forms an indistinct mass. Within it, some forms seem to suggest letters from the Urdu alphabet, written in the Arabic script; others resemble the floral illuminations that ornament Persian and Arabic manuscripts. Blended seamlessly into these are forms associated with Hindu religion and image-making, reminiscent of the *gopi*s (female cowherds devoted to Krishna) and *yogini*s (female ascetics) that are ubiquitous in the Rajput paintings of northern India. By recombining and altering canonical imagery, Sikander challenges the fixedness of categories of identity, gender, statehood, and religious affiliation.

Ink and gouache on prepared paper
196.9 x 130.8 cm (77½ x 51½ in.)
Barbara Lee Endowment for Contemporary Art by Women and Charles Bain Hoyt Fund 2006.1254

The birth and escape of Krishna, about 1590
Northern India

Akbar, the ruler of the Mughal empire in the latter part of the sixteenth century (r. 1556–1605), was a remarkably curious individual. Keenly interested in different beliefs about the nature of existence and divinity, he convened discussions at his capital between people of diverse faiths. He also ordered Hindu texts translated into Persian and illustrated by the artists in the service of his court.

The painting at the center of this elaborate album page depicts a scene from the *Harivamsa*, or "Genealogy of Hari" (Hari being another name for Vishnu). This Sanskrit text, the oldest parts of which date to the first or second century BCE, relates the life of Krishna, an incarnation of the god Vishnu. Here we see Krishna at a moment early in his life. In a technique common among illustrators of Hindu texts like the *Ramayana*, there are two different events depicted on a single page. In the first scene, at center right, Krishna's father holds his hands together in a pose of supplication (*anjali mudra*) before the blue-skinned infant god. In the second scene, at the bottom of the page, Krishna's father carries his son out of the palace, undetected by the sleeping guards.

Despite its Hindu subject matter, in style the painting follows the practice of the Mughal imperial workshop, which served a Muslim emperor, Akbar. While all of the Mughal rulers were Muslims, they differed significantly from one another in their beliefs and practices. Akbar seems to have been particularly open-minded and innovative. Right around the time this painting was made, he led the formation of an eclectic mystical movement called Din-i-Ilahi (Divine Faith) that took ideas from Islam and Hinduism as well as Zoroastrianism and Christianity.

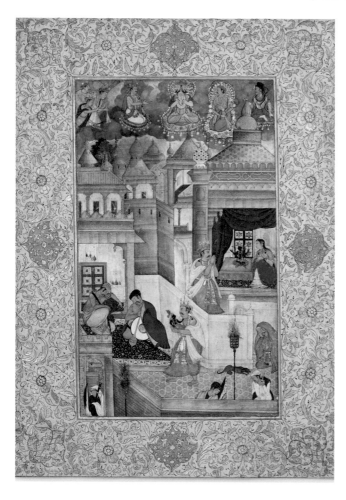

Opaque watercolor and gold on paper
22.2 x 11.7 cm (8¾ x 4⅝ in.)
Gift of John Goelet 66.148

Iskandar the fisherman finds the infant Darab in the water, about 1570
Page from a *Hamzanama*
Northern India

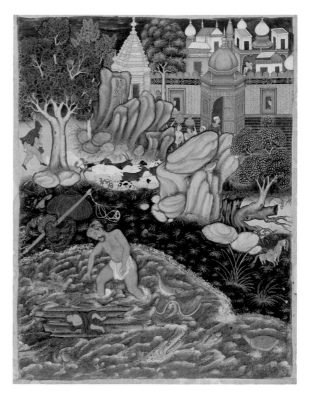

The Persian romance known as the *Hamzanama* combines elements of many stories from works of both oral and written literature, some ancient and others from later periods. Woven together, these form a fantastic, action-filled tale of heroes and demons. Hamza, the protagonist, is a combination of historically known and legendary figures, a symbol of piety and heroism. While the stories of Hamza were popular and known throughout Islamic lands, they also found audiences in India. This page is from the most magnificent copy of the *Hamzanama* ever made, produced for the Mughal emperor Akbar in the third quarter of the sixteenth century. In the foreground of the painted side of the folio, a fisherman discovers Hamza's newborn son floating on a raft, his mother having died at sea. The sea froths with waves and aquatic creatures as the fisherman bounds in to rescue the baby. Behind him are a rocky landscape spotted with verdant trees and a walled city crammed with buildings.

Akbar was a new and young emperor when he commissioned this gargantuan manuscript—twelve volumes of oversized folios like this one, with a hundred folios in each volume—and it is easy to imagine that he was captivated by the exciting stories. Akbar's workshop, led by artists trained in Iran, would have needed to expand in order to produce the *Hamzanama*. At least thirty painters were employed in the workshop at this time; most of them were local, and many were Hindu. The first group of paintings was heavily Persian in style, but over time new elements began to appear: local fashions, flora and fauna, and architecture, along with other motifs taken from European art, which came to the attention of the court through prints and paintings brought by diplomats, missionaries, and merchants. By the time the final pages of the *Hamzanama* were produced, the Mughal artists had created a new style of painting that was completely their own, combining elements from Islamic, South Asian, and European art to bring diverse strands of culture together. These artists were of many faiths, integrated into the court of Akbar, a charismatic ruler who carefully cultivated a royal image that would make him acceptable to and admired by subjects regardless of their religion.

Ink, color, and gold on a textile support mounted on paper
68.5 x 52 cm (27 x 20½ in.)
Horace G. Tucker Memorial Fund and Seth Augustus Fowle Fund 24.129

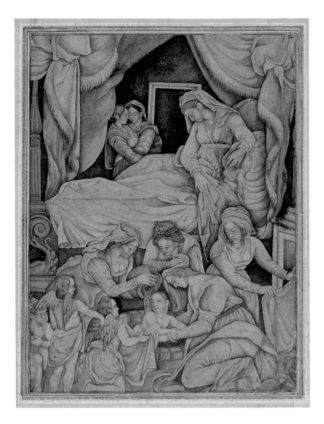

Birth of the Virgin, about 1610
Copy of a 1581 engraving by Julius Goltzius (about
1550–1595, Netherlandish), after a print by Cornelis
Cort (1533–1578, Netherlandish), after a painting by
Taddeo Zuccaro (1529–1566, Italian)
Northern India

European engravings, many with Christian sub-
ject matter, made their way to the Mughal court
in the late sixteenth century, often in the hands
of Jesuit missionaries whose presence Emperor
Akbar eagerly sought. Akbar also commissioned a
Persian text on the life of Christ from a Jesuit priest,
an illustrated manuscript of which was made by
Mughal artists in the early 1600s. This particular
work, probably made just a few years later, is a
Mughal version of a 1581 engraving depicting the
birth of Mary by the Netherlandish artist Julius
Goltzius. The Mughal artists followed the print's
composition closely, but they also made a range of
alterations, such as the addition of color and the
insertion of a doorway in the background.

Many works of Mughal art incorporate Chris-
tian imagery (see p. 52). Beyond Akbar's own strong
interest in Christianity, Mughal artists and patrons
seem to have treated images of Mary and Jesus as
powerful representations of semidivine and divine
power on earth. This would have resonated with
their own notion that the emperor possessed *far* (a
Persian term meaning "divine light"). In addition,
the Qur'an itself includes many references to Mary
and describes her as an exalted model for Muslims
to follow. In fact, both Akbar's and Jahangir's moth-
ers were called Mary or Maryam.

Ink and light wash on paper
21.6 x 17 cm (8½ x 6¾ in.)
Bartlett Collection—Museum purchase with funds from the
Francis Bartlett Donation of 1912 and Picture Fund 14.687

Christ as the Good Shepherd, 17th century
Goa, India

The diverse population of colonial port cities on
the western coast of India encompassed a variety
of religious traditions. Christian communities in
particular thrived in Goa, a Portuguese colony since
the sixteenth century. Settlers and missionaries
from the four main orders—Augustinian, Jesuit,
Dominican, and Franciscan—provided a market for
sacred objects, such as this image of Christ as a "good
shepherd."

The notion of Christ as a shepherd willing to lay
down his life to save his flock is rooted in Roman
art but was adapted early on by Christians. In the
seventeenth century, ivory carvers in Goa created a
new way to represent this idea. Here Christ sits with
a lamb in his left hand and a water flask at his waist.
Beneath his feet is a fountain of life flanked by two
small figures and surrounded by sheep; Mary Magda-
lene reclines in a cave below, reading scripture.

Some scholars, noting that this depiction of Christ
as a shepherd is not seen outside of India, have pos-
ited a connection between the serene sleeping Christ
and representations of Buddha that show him equally
inward-facing and tranquil. Indian ivory carvers
would have had ready access in this period to Bud-
dhist sculptures and may have borrowed aspects of
these images (see, for example, p. 86).

Ivory
22.5 x 7.4 x 6.6 cm (8⅞ x 2⅞ x 2⅝ in.)
Gift of E. Royall Tyler 30.155

Seated Buddha with bodhisattvas

about 8th century CE

Kashmir region, Northern India or Pakistan

Ivory objects from South Asia tend to be deluxe objects made for use by elites and rulers, not sacred images or ritual implements. The small ivory sculptures of the Buddha and bodhisattvas found in Buddhist art are an exception.

These objects epitomize the mobility of religious communities in South Asia. This particular sculpture of the Buddha with two attendants, for example, was made around the eighth century in Kashmir; it would not have stayed in the northern region, however. Throughout the second half of the first millennium CE, Kashmir was a major center of Buddhist learning: the pious traveled there from all across Asia to study, and monks journeyed outward to spread the teachings of the Buddha. Many of these small sculptures were later brought to Tibet by Buddhists who had traveled to Kashmir to study. It is likely that ivories like this one were used as portable altars during the long journey home or on pilgrimages to other Buddhist centers.

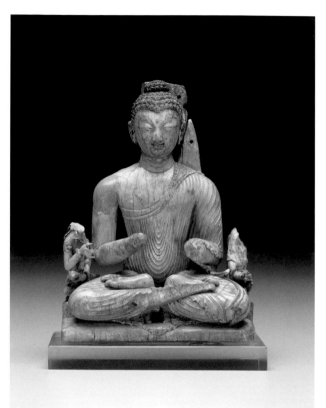

Ivory with traces of color

13.8 x 10.4 cm (5⅜ x 4⅛ in.)

Charles Bain Hoyt Fund, Marshall H. Gould Fund, and John Ware Willard Fund 63.1495

Tympanum from a Buddhist structure

1st century CE

Uttar Pradesh, India

From about the third century BCE to the seventh century CE, a large proportion of people in South Asia followed the teachings of the Buddha. Buddhism continued to flourish in certain regions during the centuries after the end of the Gupta empire around the late sixth century CE, most famously at the great monasteries in Bihar and Bengal, but by about 1200, the religion—underfunded and with great competition from devotional Hinduism—had effectively disappeared from the Indian subcontinent.

At its height, Buddhism attracted great numbers of adherents, both monastics and laypeople, and the support of powerful political figures, enabling monasteries and sacred sites to become elaborate and beautifully decorated. This architectural fragment adorned one such monument. Carved in relief, the tympanum depicts fantastic creatures and symbols of the Buddha. One side shows winged men with the bodies of lions emerging from the crocodile-like mouths of mythical *makara*s to pay homage to the Buddha's begging bowl and the bodhi tree under which he achieved enlightenment. On the other side, human and animal figures spill from the mouths of the *makara*s and approach a *dharma-chakra* (wheel of law) and a stupa (Buddhist reliquary).

This mixing of Buddhist symbols with fantastic human and animal beings is evidence of the coming together of Buddhism with local practices of nature worship found across South Asia. For example, *makara*s, closely allied with water, reverence for which is ancient and widespread in South Asian systems of belief, are integrated here with Buddhist imagery.

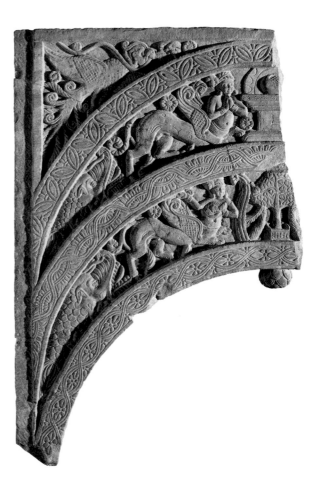

Sandstone

77.6 x 53 x 7 cm (30½ x 20⅞ x 2¾ in.)

Charles Amos Cummings Bequest Fund 26.241

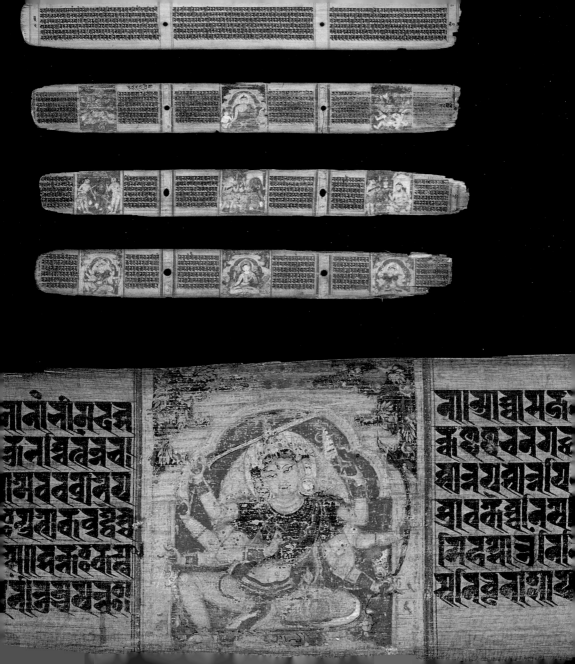

Illustrated manuscript of the *Ashtasahashrika Prajnaparamita*
about 1135
West Bengal or Bihar, India

Great monastic centers, where Buddhist teaching and pilgrimage took place, were also centers for the production of manuscripts, which were written on specially prepared palm leaves—the preferred material for manuscript production before the introduction of paper in South Asia. This is a complete early manuscript of the *Ashtasahashrika Prajnaparamita*, or "Perfection of Wisdom in Eight Thousand Verses," an important Sanskrit text within Mahayana Buddhism. Followers of this branch of Buddhism revere Shakyamuni Buddha (the historical Buddha) and other Buddhas, as well as bodhisattvas, individuals who postpone their enlightenment in order to come to the aid of other sentient beings.

The text of the *Ashtasahashrika Prajnaparamita* focuses on the worship and emulation of these important Mahayana figures, and Prajnaparamita herself (goddess of wisdom, a personification of the text) appears at the center of the first folio. The illustrated folios at the center of the manuscript depict deities belonging to the Vajrayana or Tantric tradition of Buddhism. Multi-armed and standing in wrathful poses, these gods introduce to the manuscript ideas based in Esoteric Buddhist schools of thought, which were also committed to the Prajnaparamita doctrine. The paintings may have been intended to act as an amulet to protect the manuscript, to provide its maker with the spiritual merit associated with the production of religious images, or to give the reader a focal point for meditation.

Ink and opaque watercolor on palm leaves and wood
Each: 6 x 52 cm (2⅜ x 20½ in.)
Harriet Otis Cruft Fund 20.589

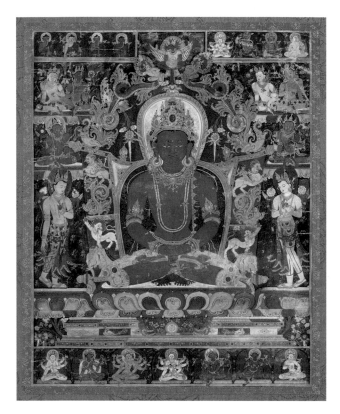

Amitayus, 13th or 14th century
Probably central Tibet

This painting originally would have been mounted in the format of a *thangka* (hanging scroll with textile borders). In subject matter, composition, and figural types, it is similar to Buddhist manuscripts and sculptures made in eleventh- and twelfth-century northern India (see, for example, pp. 88 and 132). But the religious beliefs and practices behind this painting are quite different: they are associated with the Himalayan region of South Asia, where what is today called Tibetan Buddhism emerged around the seventh century CE.

Tibetan Buddhism is a branch of Vajrayana (sometimes called Tantric or Esoteric) Buddhism. It combines teachings from Mahayana Buddhism with

Tantric and Shamanic traditions, as well as with material from an ancient Tibetan religion called Bon. The crowned and bejeweled figure in this painting is Amitayus, the Buddha of "immeasurable life," one of many Buddhas or enlightened beings who occupy the multiple realms of Tibetan Buddhist cosmology. Five such beings were featured in the set of *thangka*s to which this image once belonged, though today only two other paintings from the set are known (Ratnasambhava and Amoghasiddi).

Distemper on cotton
41.3 x 33 cm (16¼ x 13 in.)
Gift of John Goelet 67.818

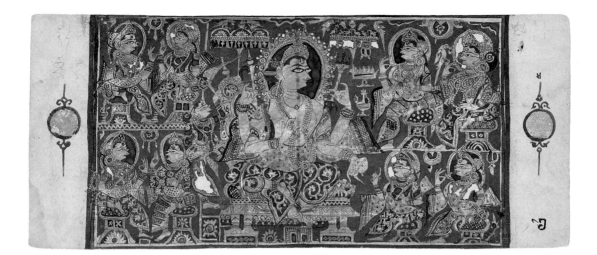

Indra enthroned, 16th century or later
Page from a Kalpa Sutra
Gujarat, India

Opaque watercolor and gold on paper
11.4 x 16.4 cm (4½ x 6½ in.)
Gift of John Goelet 66.153

The Jain religion, though closely related to Buddhism, evolved its own set of sacred texts, mythologies, and practices. Among the most important Jain texts is the *Kalpa Sutra*, which tells the stories of the lives of the Jain saints, or spiritual teachers, known as Jinas. Although the Jinas are not divine, and Jainism does not teach that enlightenment is dependent on propitiation of a god, divinities nevertheless feature prominently in Jain texts and works of art. This page from a manuscript of the *Kalpa Sutra* shows the god Indra.

Indra, shown here enthroned and surrounded by divine attendants, is among the most ancient of South Asian divinities. The Vedas describe him as a god of lightning, thunder, and storms. An important god within Hinduism, Indra also appears in Buddhism as a guardian deity and in Jainism as the king of the highest heaven, king of the gods. In the *Kalpa Sutra*, Indra serves and celebrates the Jinas. Here he perches on a golden throne, holding a thunderbolt in one hand and an elephant goad in another.

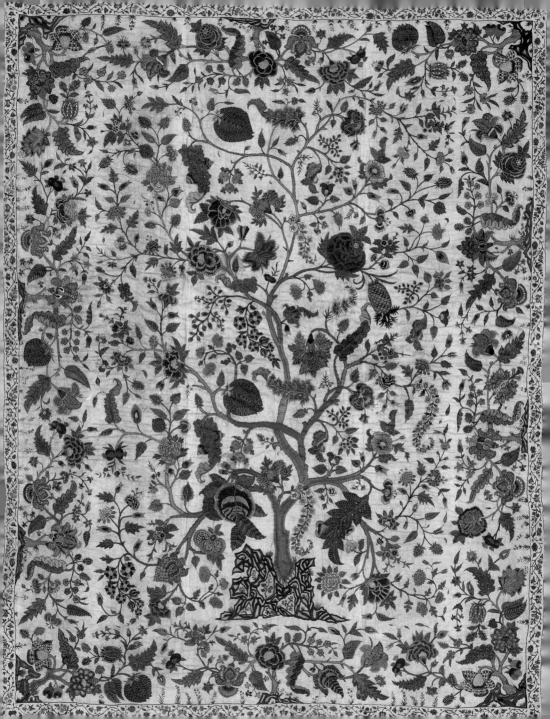

Palampore, first quarter of the 18th century
Possibly Gujarat, India

Within the central field of this extraordinary
embroidered palampore (from a Hindi word meaning
"bedspread") is a fantastical tree with blossoms of
many different kinds formed from chain-stitching
in polychrome silks. English preferences influenced
how textiles like this were composed—merchants
specially requested the tree to be shown rising up the
middle, as seen here—but the imagery itself cannot
be tied to any one specific cultural or religious source.
Chinese, European, and Indian motifs are intermixed,
and there is even a pineapple from the New World.

Trees feature in the symbolic systems of many
religions. They can be associated with specific myths
or stories and given unique characteristics, like the
fantastic *waq waq* tree that appears in Arabic and
Persian literature. They can also be emblematic
of such qualities as abundance or knowledge. For
example, after the Buddha achieved enlightenment,
the tree under which he had sat became known as
the bodhi tree and came to symbolize the journey to
spiritual awakening.

Most palampores were hand painted and resist-
dyed. This one has been carefully embroidered in
a lush array of colors so as to closely imitate hand
painting. As labor intensive as embroidery is, it
would have been less difficult than using the complex
process of mordants and resists to create such a poly-
chromatic image.

Cotton plain-weave embroidered with silk
338 x 260 cm (133⅛ x 102⅜ in.)
Gift of Mrs. Frank Clark 57.168

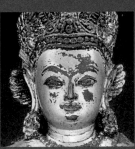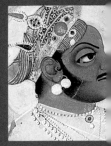

Real/Ideal

Some works of art mimic the way the world appears to the human eye more than others. In the West, this difference has often been understood in terms of a binary opposition between art that depicts the real, or natural, world and art that is abstract or fantastic, or that depicts some kind of ideal vision of the world. Although there have been moments when artists intentionally avoided creating the illusion of reality, the greater part of the history of Western art since the Renaissance has been a pursuit of naturalism, which has been equated with beauty and truth.

Artists in South Asia have also, at times, held an interest in replicating the visual appearance of the world, but this is just one among a range of different approaches. Some blur the boundaries between so-called realistic and idealistic art. For example, in a single relief at the site of Sanchi in central India, lotus flowers are shown both from above and from the side, as if the artists were attempting to replicate in stone what a flower looks like when seen from different angles.

At other times, South Asian artists have had entirely different concerns, and the beauty and power of a work of art was determined by factors other than its ability to reflect the optically perceived world. In depictions of the Buddha over many centuries, for example, artists attempted to find ways to convey the ideal of buddhahood through human bodily characteristics that could be designed and emphasized in particular ways, such as downcast eyes, which artists used to represent the Buddha's profound ability to control his inner self and thereby to open it up to enlightenment.

During the colonial era, European naturalism had a champion in South Asia. Its principles were taught in art schools set up by the British across South Asia and promoted there as the best ways to objectively represent the world and to create authenticity in art. Art created in this manner was seen as superior to indigenous non-realistic art forms, and in a sense served as a symbol of the general superiority of the West. In response, some defended South Asia's relative disinclination toward naturalism, arguing that this difference was not the

result of a lack of skill as much as it was a reflection of different goals: South Asian art was focused not on representing the world as it looks to the human eye but rather on expressing deeper and more profound truths about reality. Others argued that there was, in fact, a South Asian equivalent to the Western idea of naturalism that had been overlooked.

Western naturalism had actually been introduced to South Asia centuries earlier, when European prints and paintings were brought by missionaries, diplomats, merchants, and others to the Mughal court. There, these new images were subjected to close study. They were admired and copied, and some of their elements were incorporated into new works of art. Yet there was no wholesale adoption of a naturalistic aesthetic.

In the latter half of the nineteenth century, however, the colonial art schools spurred a more intense engagement of South Asian artists with European art. This time, the introduction of regional artists to European art was part of a broad effort to instill in South Asia the cultural values of the West. From 1850 to 1900, South Asian artists responded by taking themes and subjects of local art and depicting them in academic European styles. By the early twentieth century, however, anticolonial nationalism inspired many artists to turn back to their heritage and seek new styles and forms that were rooted in South Asia's own traditions. In many cases, this meant rejecting naturalism.

Containing objects that reflect naturalism, extreme stylization, and everything in between, this chapter illustrates the limits of the real/ideal binary. Each object was produced using realistic, abstract, symbolic, and other modes of representation, often in combination with one another. Cumulatively, they make clear that the real/ideal binary is an oversimplification of the panoply of strategies available to artists in South Asia.

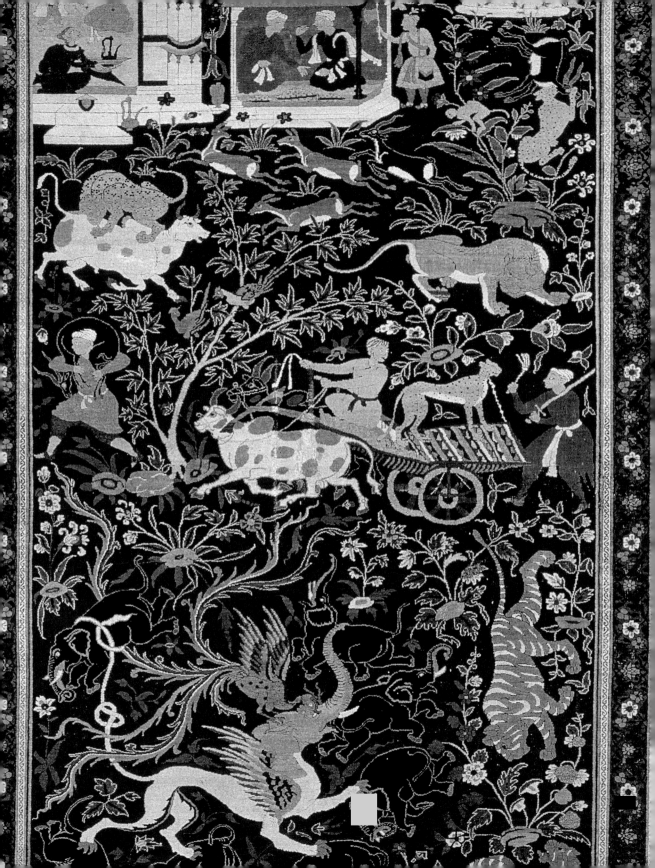

Portrait of Bhim Singh, painting about 1650,
folios and borders about 1650–58
Ascribed to Hunhar (mid-17th century, Indian)
From the *Late Shah Jahan Album*
Delhi area, India

Wearing a translucent *jama* (robe), a gold
floral sash, a red and gold turban, and a
pearl necklace, this gentleman is outfit-
ted in the fashions popular among elites
in early modern northern India. This is
no generic wealthy Mughal nobleman,
however; he is an important figure in the
Mughal and Rajput political world of the
seventeenth century. Bhim Singh
(d. 1626) was the son of the last inde-
pendent ruler of the Rajput kingdom
of Mewar, which was conquered and
absorbed by the Mughal empire in 1615.
Bhim Singh became a Mughal courtier
and was eventually given the title of
maharaja by the Mughal emperor Shah
Jahan. The painting was made during
Shah Jahan's reign and bears an inscrip-
tion in his hand, identifying the subject
and the artist.

Portraits like this were commissioned
in large numbers by Mughal rulers in
the sixteenth and seventeenth centuries,
when South Asia's artists and patrons
became engaged with European natural-
istic methods of depicting human beings.
The Mughal rulers, who were deeply
committed to documenting their reigns
and subjects, found their artists could use these new
techniques to create a record of not just the identity
and rank but also the appearance of many of the
South Asian elites who were coming under the rule of
the Mughals in the early years of the empire.

Opaque watercolor and gold on paper
37.9 x 24.7 cm (14⅞ x 9¾ in.)
Gift of John Goelet 60.172

Arjun Singh of Kota admiring a horse

about 1720

Kota, Rajasthan, India

At one time, a painting such as this would have been assigned purely to the category of the ideal rather than the real, even though it depicts a historical figure: Arjun Singh, who briefly governed the Rajput kingdom of Kota in 1720–23. The image focuses on symbolic representations of Arjun Singh's royal character, such as the gold halo around his head and the peacock-feather fan that is being used to cool him, both emblems of high status. The weapons on view (bow, arrow, sword, and shield) suggest that he has impressive martial abilities.

Just a few individual aspects of Arjun Singh's visual appearance are delineated in the painting—his sharply pointed nose, for example—but the portrait was nevertheless intended to represent this specific individual. With its distinctive profile, the main figure is recognizable as Arjun Singh to anyone who had seen other paintings of him. Unlike the Mughal portrait of Bhim Singh, the subject of this image and its patron were probably one and the same; the goal was to serve up an image that would both flatter the patron and make him recognizable to those whom he wished to impress.

Opaque watercolor and gold on paper

38.4 x 51 cm (15⅛ x 20⅛ in.)

Gift of John Goelet 66.147

One-horned animal, 2600 BCE–1700 BCE
Chanhu-Daro, Sindh, Pakistan

Ancient Greek and Roman sources trace the origins of the unicorn to the Indian subcontinent, an attribution that seems to be supported by the material record of the vast Harappan culture that formed in the Indus River valley in Pakistan and northwestern India during the third and second millennia BCE. One of the primary types of objects that survive from Harappan sites are seal-amulets, about 70 percent of which bear images of one-horned animals resembling this terracotta figurine.

That so many seal-amulets found across such a large area depict the one-horned animal suggests that it must have been an important symbol. According to one theory, it was the emblem of a powerful clan involved in long-distance trade, but as the Indus script has not yet been deciphered it is difficult to draw firm conclusions. This figurine offers a rare opportunity to see more fully how this mythical creature was imagined. It also suggests that the animal may have had ritual significance, since Indus figurines seem likely to have been used in domestic rituals.

Terracotta with red painted decoration
Length: 4.6 cm (1¾ in.)
Joint Expedition of the American School of Indic and Iranian Studies and the Museum of Fine Arts, 1935–1936 Season
36.2210

Head of a Buddha, mid-5th century CE
Mathura, Uttar Pradesh, India

A large proportion of South Asian Buddhist art is composed of works that depict the historical Buddha, who lived in the sixth–fifth century BCE. Sometimes artists depict the Buddha as a man, while at other times he is represented by symbols such as a wheel or stupa. Even when the Buddha is shown as a man—and Buddhists do believe that he lived an ordinary human life until he died and achieved *moksha*, release from the cycle of rebirth—it is often clear that his bodily or facial features have been chosen in order to represent facets of his unique humanity rather than to faithfully re-create a particular physical appearance.

In this head, a fragment of a larger sculpture, a number of features stand for various aspects of the Buddha's remarkable nature and the events of his many lives. First of all, his head is covered with curls of hair, despite the fact that as a monk his head would have been shaven; some scholars believe that the hair may have been intended as an indication of his super-human nature. A second feature is the hair-covered bump on his head, known as an *ushnisha*, which represents the Buddha's wisdom. His long earlobes signify his letting go of the wealth he had as a prince early in life, and his realization that possessions and the desire for them bring only suffering.

This sculpture also departs from naturalistic representation in another sense: the features of the face, as in much art from the Gupta period (second–sixth century CE), are stylized. The head is egg-shaped, the eyes and brows are arcs, and the ears and hair curls are more schematic than naturalistic. The mouth of this particular sculpture appears full and soft, but most other facial features were derived from nature rather than designed to imitate it.

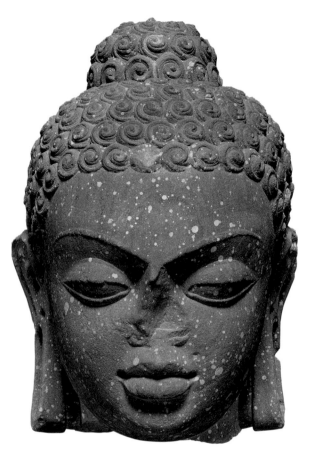

Sandstone
32.3 x 23 x 22.9 cm (12¾ x 9 x 9 in.)
Marianne Brimmer Fund 21.2230

Vishnu in his universal form

9th–10th century CE
Nepal

In the *Bhagavad Gita*, a sacred
Hindu text that is part of the great
Sanskrit epic the *Mahabharata*,
Vishnu appears before the hero
Arjuna in the form of Vishvarupa
(from the Sanskrit meaning "hav-
ing all forms") in order to awaken
Arjuna's understanding of the mys-
teries of the universe. For Arjuna to
be able to see this universal form of
Vishnu, he must first be equipped
with supernatural sight. Only then
is he able to see the god in all his
infinite multiplicity, described in
the *Bhagavad Gita* as "a multiform,
wondrous vision, with countless
mouths and eyes, and celestial
ornaments, brandishing many
weapons . . . If the light of a thou-
sand suns were to rise in the sky at
once, it would be like the light of
that great spirit."

In this sculpture, the artist
has been judicious in choosing
which aspects of the vast and all-
encompassing form of Vishvarupa
to represent. The many mouths and
eyes are not shown, but the god does have ten arms,
each one holding an attribute: discus, sword, battle
ax, bow, lotus seed, elephant goad, shield, mace, and
conch shell. This economy was well warranted: the
artist could not hope to capture the universal nature
of divinity in copper and gold any more than Arjuna
could apprehend Vishnu's true nature with ordinary
human eyes.

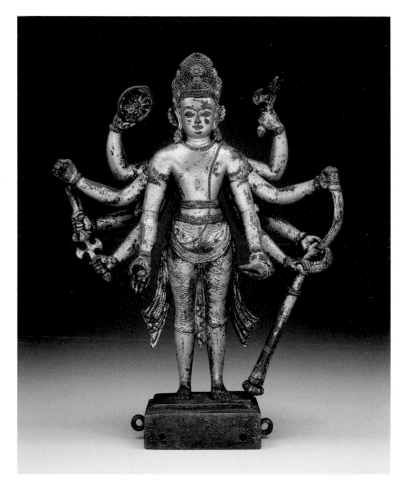

Gilt copper
31.8 x 22 cm (12½ x 8⅝ in.)
Keith McLeod Fund 67.5

Indra praising Mahavira, about 1500
Attributed to the Master of the Devasano Pado *Kalpa Sutra* and *Kalakacharya Katha* (late 15th century, Indian)
Page from an illustrated manuscript of the *Kalpa Sutra* and *Kalakacharya Katha*
Patan, Gujarat, India

The god Indra, shown seated on the left side of this painted page, raises two of his hands in a gesture of praise and respect. He is celebrating the birth of Mahavira, the last of the twenty-four enlightened teachers of the Jain religion (Jinas). Mahavira himself is not depicted on the page, as he has not yet been born. According to the *Kalpa Sutra*, a text that narrates Mahavira's life and that of the other Jain teachers, his embryo was moved by a divine being from the womb of one woman to that of another so that he could be born into a family from the ruling or warrior caste. In the Jain tradition, Jinas (meaning "conquerors" in Sanskrit) are conceived of as spiritual warriors.

Jain manuscripts are known for having beautiful, bold paintings, usually in a palette of red, blue, gold, and white. Generally, the artists who made them did not employ shading or other techniques to suggest depth or volume. Indra is depicted here in this typical manner. The rest of the page, however, is quite different. It has an extended palette including pinks and light blues and greens, giving it an unusual sense of naturalism.

The page belongs to a famed manuscript known as the Devasano Pado *Kalpa Sutra* (the majority of which is still held in the Devasano Pado temple library in Ahmedabad, India). The manuscript is unique in its visual richness and complexity, as well as in its use of rich blue pigment made from lapis lazuli. The manuscript's colophon records that it was made for the family of a minister, probably one who served the sultanate that ruled much of India in this period.

Opaque watercolor and gold on paper
11.3 x 26.2 cm (4½ x 10⅜ in.)
Gift of John Goelet 66.152

Dying Inayat Khan, 1618–19
Attributed to Balchand (active about 1595–1650, Indian)
Northern India

Inayat Khan, the subject of this remarkable portrait, was a courtier who served the Mughal emperor Jahangir in the role of paymaster-general. He became very ill from addiction to opium and alcohol, and in 1618 Jahangir wrote of him that "he looked incredibly weak and thin. . . . Even his bones had begun to disintegrate. Whereas painters employ great exaggeration when they depict skinny people, nothing remotely resembling him had ever been seen. Good god! How can a human being remain alive in this shape? . . . It was so strange that I ordered the artists to draw his likeness. . . . He died the second day."

Among the artists asked to depict Inayat Khan was Balchand, a painter who had joined the Mughal imperial workshop in the 1590s. From the very beginning of his career, Balchand had painted portraits of Mughal rulers and elites, combining elements drawn from close observation with conventions indicating status, wealth, and other attributes of his subjects. Here Balchand appears to have made a great effort to put down on paper only what he saw with his own eyes, from Inayat Khan's protruding ribs to his scraggly beard. Like many other artists in the Mughal atelier at this time, Balchand was familiar with naturalistic European prints and paintings. His attention to the particular physiognomy and condition of Inayat Khan can be attributed both to this exposure and to Jahangir's personal dedication to having his artists accurately record the appearance of unique people and animals he encountered.

Ink and light wash on paper
10.5 x 13.3 cm (4 ⅛ x 5 ¼ in.)
Bartlett Collection—Museum purchase with funds from the
Francis Bartlett Donation of 1912 and Picture Fund 14.679

An Elegant Man, 1584–90

Ascribed to Aqa Riza (active in India about 1580–1620, Persian)

Possibly Lahore, Pakistan

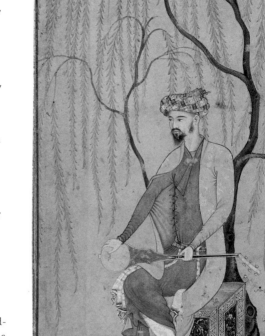

This graceful, stylized image presents a striking contrast to the realism of the drawing of Inayat Khan, though it was painted by an artist who worked alongside Balchand in the Mughal atelier. Aqa Riza was born in Herat, Afghanistan, but emigrated while in his twenties to South Asia, where he found patronage under Prince Salim, who later became the emperor Jahangir. Jahangir's tastes appear to have been expansive, as he supported artists working in a range of styles. In this painting, the European naturalism of the Inayat Khan portrait is replaced by an otherworldly sumptuousness that comes from Persian courtly painting. With his elongated torso and loosely tied turban, this impossibly elegant gentleman resembles figures painted for the Safavid rulers of Iran in the late sixteenth and early seventeenth centuries.

Despite being highly stylized, the painting may in fact represent a particular individual. It closely resembles a painting of the Mughal emperor Akbar's half-brother Mirza Muhammad-Hakim, who was a Mughal courtier and patron of the arts.

Opaque watercolor and gold on paper

14.7 x 8.2 cm (5¾ x 3¼ in.)

Bartlett Collection—Museum purchase with funds from the Francis Bartlett Donation of 1912 and Picture Fund

14.609

Birth of Prince Salim, about 1620

Attributed to Bishandas (active about
1590–1640, Indian)

Page from a *Jahangirnama*

Northern India

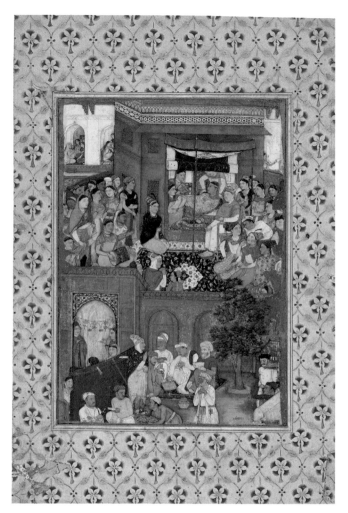

As early as the late sixteenth century,
the interest of the Mughal dynasty in
documenting the reigns of its members
had led to the production of a great many
portraits of courtiers and rulers as well
as paintings depicting important events.
Many such images were made to illustrate
the official history of an emperor's reign.
This image, from a copy of Jahangir's
illustrated memoir—the *Jahangirnama*—
made during his own reign, seems to
represent his birth (at which time he was
known as Prince Salim). It shows in great
detail the private world of the women's
quarters of a Mughal palace, constructed
in the typical red sandstone and white
marble of early Mughal architecture. In
addition to depicting the mother of the
child, many female servants, and several
generations of female relatives, the artist
has taken pains to include attendants
bringing sweets and astrologers casting the child's
horoscope outside the walls of the women's quarters.

The artist has gone to great lengths to give the
many different female figures individualized facial
features (for example, different skin colors). While
this suggests direct observation, the artist was
almost certainly a man and thus would not have had
access to the women's quarters. Some of the female
figures are therefore probably better understood
as generic despite their "realistic" treatment. Oth-
ers, however, may have been intended to represent
specific individuals. The mother of the child must be
Emperor Akbar's wife, who was a Rajput princess,
and the figure seated next to her on a gold throne
must be Hamida Begum, Akbar's mother.

Despite all of this effort to document accurately
the world of the Mughal emperors, there are certain
elements that are simply not intended to reflect opti-
cal reality. Around the head of the newborn child, for
example, is a faint halo.

Opaque watercolor on paper
26.4 x 16.5 cm (10⅜ x 6½ in.)
Bartlett Collection—Museum purchase with funds from the
Francis Bartlett Donation of 1912 and Picture Fund 14.657

Woman at her bath, about 1690–1700
Possibly Basohli, Punjab Hills, India

Depictions of a generic female figure bathing were popular in the eighteenth century among the painters of the Rajput kingdoms in the Punjab Hills. These images often show a woman wringing out her hair, having her body washed, or fixing her jewelry, perhaps in anticipation of her lover's arrival. Unlike the painting of the birth of Prince Salim, there is no wall surrounding the figure and protecting her from the eyes of strangers or men, but the image nevertheless gives the viewer the sense of glimpsing a private moment.

Although there are few clues as to the context of the scene, the inclusion of a tree, a bird, and a bit of grass suggests that the figure is in a garden or other natural setting. Perhaps she has bathed in a stream, and the painting depicts her after she has come out of the water and is drying off. These are the slimmest of hints, however, as the artist clearly intended to emphasize the interplay of long, curving outlines and tapering forms set off by the plain red background, rather than features of a specific setting or figure.

Many Rajput artists were dedicated to the representation of intense emotional, spiritual, or physical states, reflected here by the saturated color of the background and the piercing gaze of the woman. This image can be interpreted as depicting the heroine Radha as glimpsed by her divine lover, Krishna, evoking emotions of longing and desire.

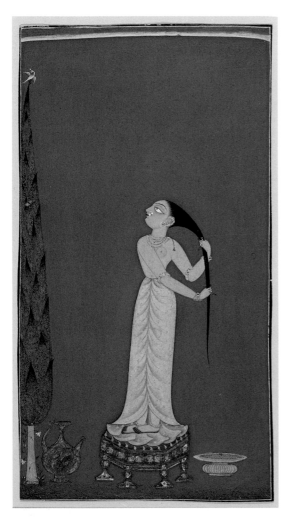

Opaque watercolor, gold, silver, and beetle carapace
on paper
22.3 x 11.9 cm (8¾ x 4⅝ in.)
Ross-Coomaraswamy Collection 17.2798

Shiva watches Parvati sleep, about 1780–90
Probably Garhwal, Punjab Hills, India

This quiet painting of a couple enjoying some time together could be a scene from any romance. Naturalistic colors and a series of tree-dotted hills arranged to convey receding space combine to create a lush countryside setting perfect for a tryst. Various details indicate, however, that these are no ordinary lovers on an outing. The male wears a crescent moon in his hair, his trident and drum are parked nearby, and his mount—a white bull—rests in the shade of a large rocky outcropping. Underneath the lounging couple is the leopard skin often seen with Shiva. Although there are no specific clues as to the woman's identity, if her companion is Shiva she must be his consort, the goddess Parvati.

Hindu mythology holds that Shiva and Parvati live as wandering ascetics in the Himalayas. Here, however, signs of the more strenuous and severe aspects of their lifestyle are muted. Shiva, depicted as the embodiment of great destructive energy in other South Asian contexts, was often shown in this relaxed and loving guise in paintings made in the Punjab Hills in the late eighteenth and early nineteenth centuries. The naturalistic aspects of this treatment signal the impact of the semi-naturalism of late Mughal painting.

Opaque watercolor on paper
29.5 x 21.3 cm (11⅝ x 8⅜ in.)
Ross-Coomaraswamy Collection 17.2652

Krishna and Radha celebrate Holi

about 1750–60

Attributed to Nihal Chand

(active in the mid-18th century, Indian)

Kishangarh, Rajasthan, India

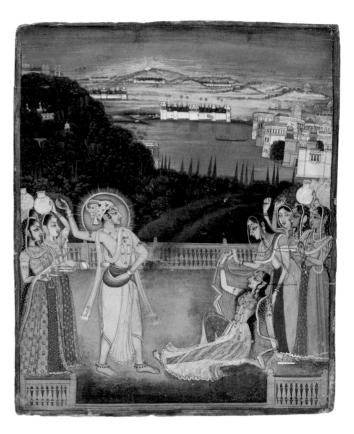

Optical realism was perhaps the furthest thing from the mind of the artist who created this technicolor image. It belongs to a group of paintings depicting the *lila*s (divine acts) of Krishna and Radha made in the Rajput kingdom of Kishangarh, where the ruler was an ardent devotee of Krishna. These images are known for their lush, expansive landscapes and distinctive figures with stylized features— the extended, swooping eyes, for example. Of all the works by the Kishangarh master artist Nihal Chand, of which this may be one, the paintings of *lila*s tend to be the most stylized, with highly burnished layers of paint and abundant use of gold.

At the springtime festival of Holi, celebrated across South Asia, people throw colored powder at one another. Here the arcs of powder that fly through the air are overshadowed by the intense salmon color of the foreground, the colorful clothing, and the shining horizon, all set against a dark green hillside. The colors give the image a heightened sense of drama, utterly different from the image of Shiva and Parvati in the countryside.

Opaque watercolor and gold on paper

19.4 x 15.9 cm (7⅝ x 6¼ in.)

Keith McLeod Fund 2002.901

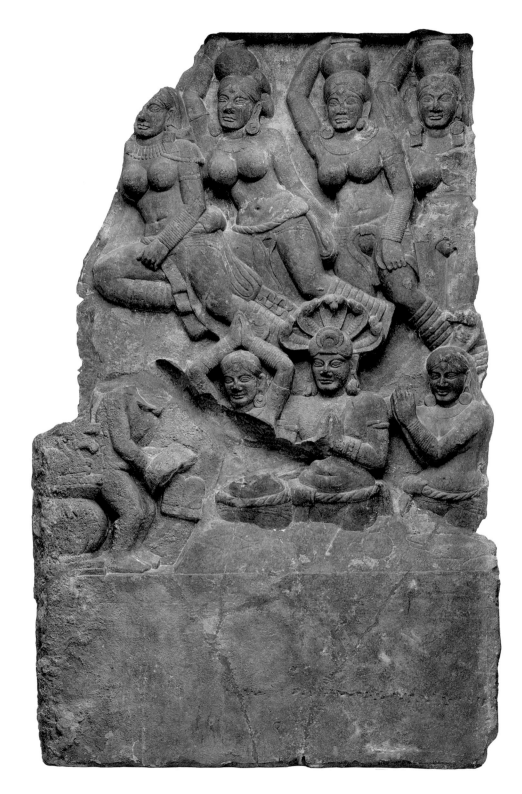

Slab from the wall of a stupa, front carved in early
2nd century CE, back carved in 3rd century CE
Andhra Pradesh, India

Although the prince Siddhartha Gautama, who would become the Buddha, is the main character in the story told in this relief, he is nearly invisible, represented only by a symbol: a pair of footprints bearing *chakra*s (wheels representing the Buddha's teaching) in the lower left, next to a figure holding a cloth with which to dry Siddhartha after he has bathed in the Nairanjana River. Depicting him this way was common at the time the scene was carved. The many other figures present are minor divinities. At the bottom, a snake god and his two wives rise out of the river. Above, four celestial ladies fly through the air carrying pots of water. The appearance of these supernatural beings is an affirmation that Siddhartha would eventually become a Buddha, an enlightened one.

The divinities in the relief are given robust bodies that suggest actual mass and volume. Their materiality and physicality is especially striking in comparison with the symbolically rendered Buddha, the one individual in the scene who was unquestionably human. Why many South Asian artists during the first few centuries CE chose to depict the Buddha with emblems is not fully understood.

Artists reused the slab about a century after this relief was made. On the other side, they carved a richly decorated stupa like the one to which the slab once belonged. At the front of the stupa is an image of the Buddha in the form of a man.

Limestone
157.6 x 94 cm (62 x 37 in.)
Denman Waldo Ross Collection 29.151

Carpet, about 1590–1600
Probably Lahore, Pakistan

This is the most famous example of a remarkable type of Mughal pictorial carpet designed to be viewed in a vertical orientation, like a painting. In the upper left is a palace scene featuring two buildings. The one on the left is shown from the front and rendered quite flatly, and resembles the architecture of Mughal India in its overall form and its ornamental details; inside, a mother holds her child by the hand while a servant sits before them holding a ewer and basin. The two-story building to the right is somewhat more three-dimensional. Inside the lower level, two men converse animatedly while a servant stands outside; on the upper level, a musician plays a horn. These scenes of courtly life, rendered in fairly naturalistic color and with spaces that convey some sense of depth, are drawn from the pictorial language of the imperial Mughal manuscript workshop. There, in the late sixteenth century, artists were experimenting with elements of Western naturalism in their depictions of scenes of local courtly life.

The imagery in the lower area of the carpet is quite distinct and bears no relation to the human or architectural environment in which the carpet was made. Rather, it features a dramatic conflict between mythical animals: a blue *simurgh* (phoenix-like bird) attacks a white winged *gaja-simha* (elephant-lion) who holds seven black elephants in its claws, mouth, trunk, and tail. Spatial recession and naturalistic color here are replaced by bold, contrasting colors and a radial composition with the two fighting animals in the center and the elephants arranged in a ring around them.

Cotton warp and weft with wool knotted pile
243 x 155 cm (95⅝ x 61 in.)
Gift of Mrs. Frederick L. Ames, in the name of Frederick L. Ames 93.1480

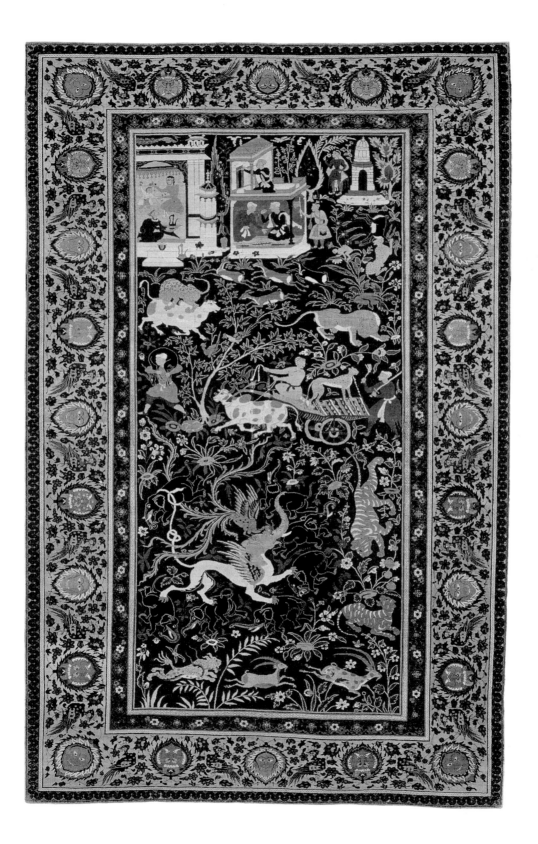

Tray, 1904
Peter Orr & Co.
Chennai, Tamil Nadu, India

This impressive tray is among the most impeccably preserved products of the Scottish firm of silversmiths founded by Peter Orr in Madras (today Chennai). By the turn of the century they were employing more than 600 Indian artists. It was made as a gift for James Neill, the captain of an Indian gold-mining company, upon his retirement in 1904.

A pair of intertwining serpents surrounds the tray, forming a continuous border and handles. Ringing the dedicatory inscription at the center of the tray are twelve delicately incised scenes of village life, a common subject of paintings and other types of artwork during the colonial period. Some of the circular vignettes on the tray depict people doing

such everyday work as washing clothes, transporting goods, harvesting coconuts, and cutting wood. Others depict special events: a Brahman priest carrying out a ritual, men charming snakes, and the meeting of two elephants carrying people in howdahs atop their backs.

In most of the scenes, both a male and a female are depicted, as if the artist was attempting to show how both sexes look and behave in each occupation. In this sense, the tray possesses the taxonomic character that is ever-present in the culture of colonial South Asia, where throughout the nineteenth and early twentieth centuries a broad attempt was made to use Western "objective" and "scientific" tools to study and document the region and render its inhabitants familiar and controllable.

Silver
53.3 x 74.3 cm (21 x 29¼ in.)
Gift of Richard Milhender 2013.793

Palankin Bearer.

Englishman being carried in a palanquin

1830–35

Attributed to Shaykh Muhammad Amir of Karraya
(active about 1830–1840, Indian)
Kolkata, West Bengal, India

During the colonial period, both European and South
Asian artists produced works of art that aimed to
record the nature of life in South Asia. Paintings of
this sort were frequently labeled with names of occu-
pations, tribes, castes, or localities. This painting may
have been made for an album of such works that was
produced for the Calcutta (now Kolkata) businessman
Thomas Holroyd, who in the 1830s commissioned the
artist Muhammad Amir to produce a series of depic-
tions of life in India.

 Fine details abound in this painting of four Indian
men carrying a palanquin in which rides an English
figure. The white *dhoti*s and turbans worn by the
bearers reflect the specific modes of dress of men in
their occupation and region, just as the white and
blue clothing of the Englishman fits his own class and
culture. Their skin colors are also notably distinct.
Details of the palanquin itself are rendered with care,
from the yellow fringe of the curtain to the ropes that
stabilize it.

 The label below the painting may read "Palankin
Bearer," but this painting says just as much about
the palanquin's rider as it does about its bearers.
One detail in particular stands out: the Englishman's
limp wrist hanging in a loop of cord. One might well
argue that the real subject of this close study is the
indolence of the British male. Naturalism, in the right
hands, can be a sharply pointed tool.

Watercolor on paper
17.8 x 24.8 cm (7 x 9¾ in.)
Charles Bain Hoyt Fund 2011.353

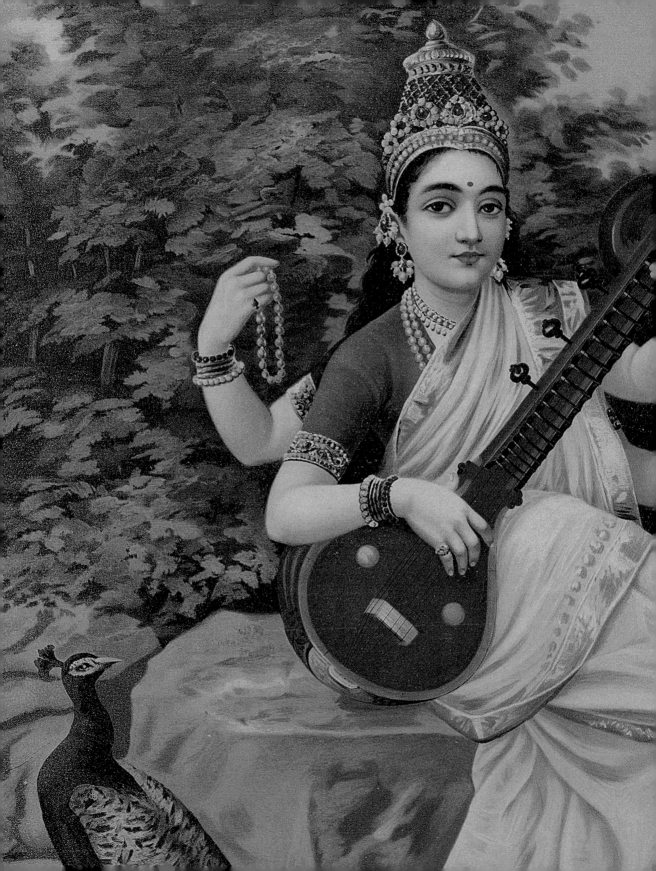

Male/Female

The idea of gender as a binary opposition of male and female is deeply rooted in many societies. Yet today those who study gender—whether through politics, art, or other lenses—generally reject dualistic approaches to describing how it works. It is simply impossible to explain something as complex as gender with a single pair of opposed concepts. The character of individuals is determined not only by sex but also by class, race, age, and nationality, among other factors. As with other dualities explored in this book, the Western male/female notion of gender had a powerful impact on the way the British ruled South Asia during the colonial era and on the way they understood and wrote the region's history.

Before that time, the gender landscape of South Asia was quite different. In certain times and places, gender was in fact articulated in terms of a male/female binary opposition, particularly in religious belief systems. The qualities attributed to male and female are, however, specific to their context and quite distinct from Western gender conventions. In some forms of Tantric Hinduism and Buddhism, for example, a male/female pairing is used to explicate ideas about the interrelationship of compassion (*karuna*) and wisdom (*prajna*); *karuna* is personified as male and *prajna*, female. Even in this context, some works of art overcome the binary even as they acknowledge it. A Tibetan sculpture of Vajrabhairava with his consort, Vajravetali, depicts the sexual union of a male and a female divinity, but it can also be understood as representing the transcendence of this male/female duality to achieve the ultimate goal of non-duality, or *advaita*.

A different way of pairing male and female is found in the arts of devotional Hinduism, exemplified by several Hindu divinities such as Ardhanarishvara and Lakshmi-Narayana. These gods are half male and half female, as described in texts and portrayed in painting and sculpture. In the case of Ardhanarishvara, the right half has the attributes of Shiva, such as a trident, while the left half represents his female counterpart. Underpinning this unifying form is the concept of *shakti*, which means "power" in Sanskrit. Shakti, which is understood to

be a female being, is the underlying power that allows a male god to be active. The two are interdependent and equal in status.

Other works of South Asian art are founded upon an understanding of gender that is not based on a binary pair at all. In the vast world of images of Hindu and Buddhist divinities, for example, many figures possess a panoply of traits that are associated with both males and females, or with neither. Even images that depict the lived experiences of men and women in South Asian societies often challenge binary thinking. Paintings of women at the Mughal court defy simplistic understandings of their roles in family, community, and society. Other paintings depict male desires for and anxieties about women in such a way that neither male nor female possesses the dominant gaze.

Works of art like these remind us that gender is not a natural facet of human life, but rather a set of historically and discursively constructed ideas about sexual difference. In addition to being constructed, gender is radically contextual, meaning that it works in different ways at different times and places. The refusal of South Asian objects to fit into a single concept of gender invites us to explore the great diversity and sophistication of the region's notions of gender and their expressions in art. At the same time, South Asian art can help us rethink the concept of gender itself and come to a more expansive understanding of how it works across the globe.

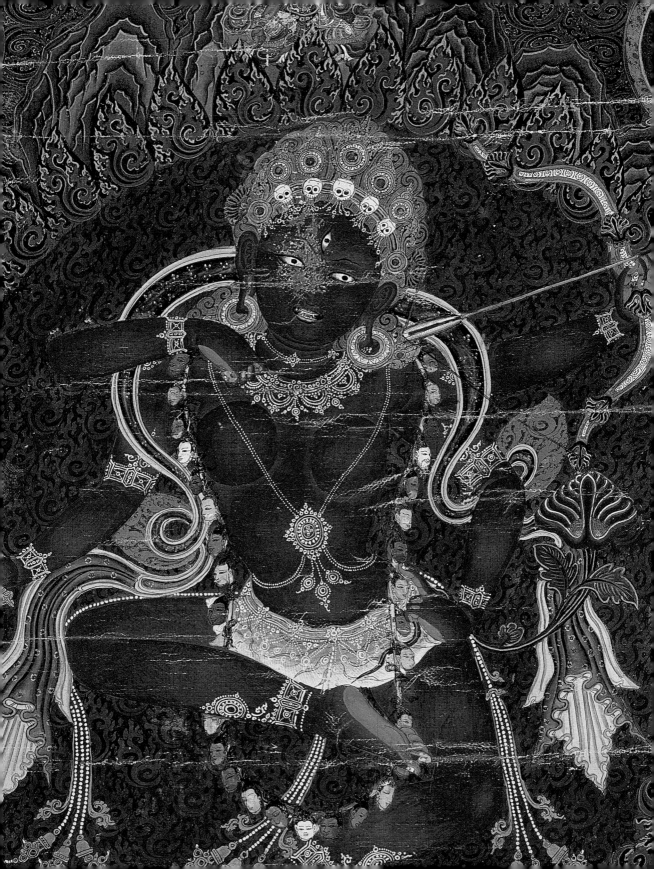

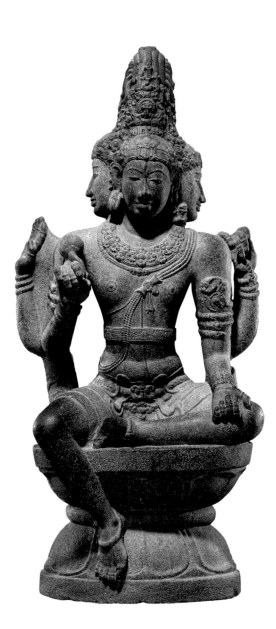

Shiva as Mahesha, late 10th century
Tamil Nadu, India

Like all major Hindu gods, Shiva is multifaceted and
can take many different forms: lord of the dance,
demon destroyer, loving husband, wandering ascetic,
and more. This sculpture—one of an unusual group of
five monumental stone images from the Chola period
(ninth–thirteenth century), all with the same iconog-
raphy—seems to have been intended to represent
him in his most regal form, as the supreme god out
of whom all others emerge. Kingly and commanding
are his erect and static posture, high lotus throne,
and towering crown. His upper right hand makes a
gesture meaning "fear not," while his lower left makes
the gesture for gift giving.

Based on the four heads, scholars have tentatively
identified this sculpture as Shiva in his manifestation
as the god Mahesha. In this form, Shiva is the cre-
ator of the other two great Hindu gods, Brahma and
Vishnu. His four faces likely represent Shiva (center),
Brahma (right), Vishnu (left), and Rudra, another
form of Shiva (on the back). Containing these other
gods within him, Shiva is absolute and supremely
powerful.

This sculpture was probably originally placed
within a niche on the exterior of a Hindu temple. In
this setting, perhaps surrounded by smaller images
of other divinities or celestial beings, Shiva would
have appeared mighty and perhaps even fearsome.
His commanding presence comes not from his mas-
culinity but from his size, gestures, and attributes, as
well as his role as the creator of all gods.

Granulite and green schist
161.9 x 74 x 53.2 cm (63¾ x 29⅛ x 21 in.)
Gift of Mrs. John D. Rockefeller, Jr. 42.120

Shiva as Vinadhara (Lord of Music)

about 900–970 CE

Kanchipuram, Tamil Nadu, India

Here Shiva is not the mighty supreme god but a performer. He has the third eye and thick locks of hair piled high upon his head that characterize his representation as Mahesha, but his other attributes are quite different. With tilted head and shoulders, arms set at varying angles from center, and hips slightly twisted, his body appears limber and full of movement, almost like that of a dancer. While his upper hands hold a drum and a skull-topped staff, his lower two hands, now missing, originally held a *vina*, a lute-like instrument. (The only remaining part of the instrument is a resonating gourd that appears over the god's left shoulder.) Sitting cross-legged with his *vina* in his lap, he seems to sway to the music.

This image of Shiva was made for a now-destroyed temple dedicated to Hindu Tantric female figures known as *yogini*s. It probably once sat among dozens of *yogini*s, each stone sculpture placed within its own niche around the interior of the circular temple. Shiva would have been one of only two male figures in the temple; it is likely that, when intact, the temple gave the impression of Shiva being dominated by the many fierce and beautiful *yogini*s around him, for whom he played. Shiva and the *yogini*s together represented the infinite manifestations of female power (*shakti*) that pervade the universe.

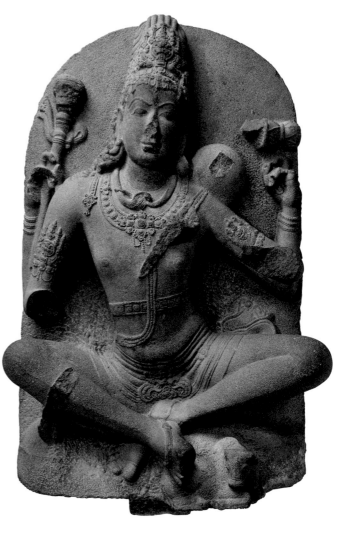

Schist

122 x 80 x 35.6 cm (48 x 31⅛ x 14 in.)

Maria Antoinette Evans Fund 33.18

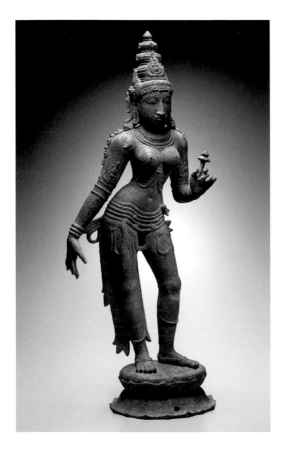

Goddess, late 11th or early 12th century
Tamil Nadu, India

This female figure wears beautiful jewels, a gossamer garment on her legs, and a spectacular crown. In one hand she holds a lotus flower. She looks like she could be a queen; however, based on many other surviving bronzes of the Chola era (ninth–thirteenth century), we know that she is in fact a goddess.

The sculpture may represent the goddess Parvati, consort of Shiva and the mother of his children. Parvati's *shakti*, or feminine power, complements the energy of the god Shiva; together the two are said to unite to bring about the creation of the universe. Originally, this sculpture may have been kept in a Hindu temple treasury and taken out on special occasions to be placed alongside an image of Shiva. The bend in her body would have drawn viewers' eyes to him.

Unlike male Hindu gods, who are generally depicted with emblems that identify aspects of their mythology or powers, goddesses are rarely accompanied by specific attributes in Chola-period bronzes. As a result, it can be difficult to differentiate them. At different times, this sculpture has been identified as Parvati, Bhudevi, and Lakshmi.

Bronze
Height: 82 cm (32¼ in.)
Keith McLeod Fund 64.1161

Durga as Mahishasuramardini (Slayer of the Buffalo Demon), 970–1070 CE
Southern India

Unlike the bronze goddess, Durga is an independent goddess and is not often considered or depicted as a consort of a god. There are a number of stories about Durga's origin and identity, but the one depicted here is her defeat of a buffalo demon named Mahisha, a tale drawn from the *Devi Mahatmya*, a Sanskrit text from about the sixth century CE. The gods Brahma, Vishnu, and Shiva were so enraged at this demon that the fiery energies within them erupted, combining to form the multi-armed goddess Durga. In this tale, she is *shakti* in human form: female power personified.

While most goddesses lend their power to male gods, Durga instead takes power from them in order to perform her own heroic deeds. She represents an image of womanhood that challenges the role of devoted wife given to women in Hindu law books. This is not to say that Durga is not a nurturer and protector: in fact, she is a kind of cosmic protector who intervenes whenever demons or dark forces threaten the world.

Carved in high relief from dark, coarse schist typical of southern India, this sculpture of Durga was once placed in a niche, probably on the exterior of a Hindu temple. She stands menacingly atop her kill, both undeniably terrifying and unmistakably feminine. Her body is long and lean, yet not lacking in rounded and soft forms. Her hip is cocked, conveying pride and confidence.

Green schist
150 x 61 x 45.7 cm (59 x 24 x 18 in.)
Denman Waldo Ross Collection 27.171

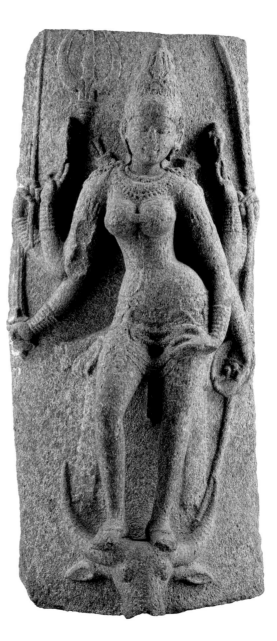

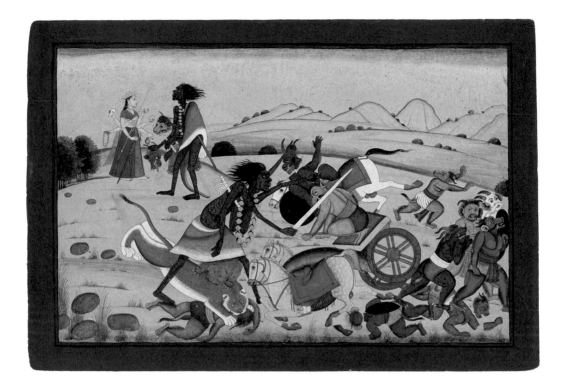

The Victory of Kali, about 1780
Page from a *Devi Mahatmya* series
Guler, Punjab Hills, India

Not all Hindu goddesses are imagined in the form of
beautiful young women. The goddess Kali is depicted
with an ugly and frightening appearance. In this
painting, she is shown with dark skin, half-naked and
emaciated, with hanging breasts, wild hair, and four
arms. Like Durga, she is associated with a story from
the *Devi Mahatmya* in which she comes to the aid of
male gods and defeats foes they were unable to van-
quish, in this case the demons Chanda and Munda.

Two scenes from the story are shown in this
vibrant painting, which once would have belonged to
a set of loose paintings relating the tale. In the fore-
ground, Kali lunges forward to behead the demons,
whose army retreats in panic. Kali appears again in
the upper left where, moments later, she presents the
heads of her still-grimacing victims to the beautiful
Devi.

Here Devi is understood as a great goddess in
whom all other goddesses are subsumed. Kali is thus
a manifestation of Devi, as are Durga, Parvati, and
others. This notion of a great goddess, and the idea
that the male gods who create, preserve, and destroy
the world act only according to her will, emerged
around the fifth or sixth century CE.

Opaque watercolor on paper
20 x 29 cm (7⅞ x 11⅜ in.)
Keith McLeod Fund 1984.529

Kurukulla, 16th century
Tibet

Like Hinduism, Buddhism contains both peaceful and wrathful female divinities. The goddess Kurukulla, depicted in this *thangka* (hanging scroll with textile borders) in red against a flaming red backdrop, wears a necklace of severed heads and dances atop a corpse. The corpse symbolizes ego, while the floral bow and arrow Kurukulla holds may be employed to subjugate and transform those she targets to free them from desire to better achieve enlightenment. Although she has three eyes and a mouth full of pointed canine teeth, her body is depicted in a manner that conforms to the same ideal of female beauty that we see in depictions of Parvati and other South Asian female figures. One Buddhist text describes Kurukulla as having "the youthful form of sixteen years."

Likely due to the prolific depiction of the male Gautama Buddha in Buddhist art, there exists a widely held misconception that the Buddhist religion does not deify females. In fact, women figured prominently even in the earliest documented pantheon of divine beings. In Buddhist theory, gender alone does not determine one's ability to attain enlightenment. In fact, *nirvana* is beyond duality and is therefore explicitly non-gendered. Additionally, doctrine central to several Buddhist scriptures states that upon enlightenment an individual's stream of being dissolves into the *dharmakaya*, or sphere of infinity. The *dharmakaya* is formless and thus cannot be spoken of in terms of male or female.

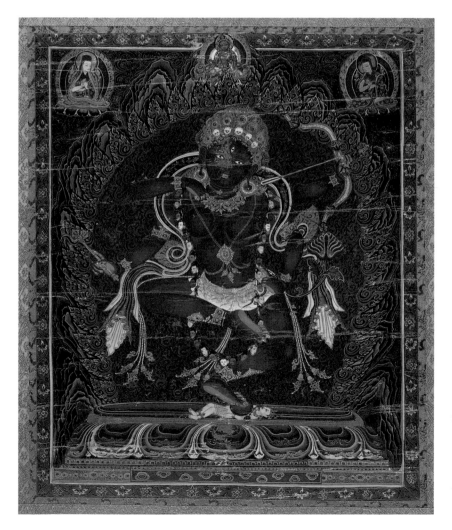

Distemper on cotton, mounted on silk brocade
40 x 32.4 cm (15¾ x 12¾ in.)
Gift of John Goelet 67.819

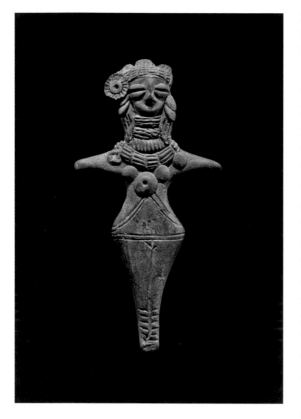

Female figurine, about 2nd century BCE–
2nd century CE
Probably Peshawar, Pakistan

This small figurine has prominent eyes, small
breasts, exaggerated hips and buttocks, short
pointed arms, and tapering joined legs. It is adorned
with elaborate jewelry from the shoulders up, but
wears little in the way of clothing. Many figurines of
this type—most female and just a few male—were
excavated in the Peshawar valley, which was home
to flourishing societies at the intersection of a major
silk route from at least the fourth century BCE. Figu-
rines like this one were made from about the second
century BCE to the second century CE; during this
period, control of the region shifted from the Mau-
ryan to the Bactrian and then to the Kushan empire.
These political shifts have added to the immense
complexity of the culture, which makes precise
interpretations of figurines like this difficult.

This figurine may represent a fertility or mother
goddess, but this is not certain. The figure has all the
attributes unique to female bodies, but aside from
the hips and buttocks they are not exaggerated; nei-
ther private parts nor child-bearing and nurturing
abilities are emphasized. For these reasons, scholars
today question calling her a fertility goddess. She is
nude, but this may symbolize age, life stage, or sta-
tus rather than eroticism. Her mode of dress and the
ornamentation on her body might be markers of eth-
nicity rather than signs of ritual or religious mean-
ing. She may look like a mother goddess to some eyes,
however, detailed examination and contemporary
theory show just how little we really know about
gender in ancient societies.

Terracotta
10.5 x 5.7 x 1.3 cm (4 ⅛ x 2 ¼ x ½ in.)
Denman Waldo Ross Collection 27.567

Nature goddess (*yakshi*), about 120 BCE
Bharhut, Madhya Pradesh, India

Many *yakshi*s (nature goddesses) and *devata*s (minor divinities) adorned the ancient Buddhist stupa at the site of Bharhut. As in this fragmentary example, these buxom female figures are beautiful, heavily adorned with jewelry, and sometimes sport facial tattoos; their long hair hangs in thick plaits that may be interwoven with flowers. This image of womanhood emerges not from observation but rather from ideals of beauty that were rooted in natural imagery. To take just one of many examples, a woman's hair is described in a Sanskrit poem of the twelfth century as surpassing the peacock's train.

This figure was most likely originally depicted on one face of a pillar in the stupa railing, with an adjacent face representing a male semidivine figure. Gender differentiation was pronounced at Bharhut: female figures like this *yakshi* were more heavily ornamented and depicted with a greater emphasis on their sex organs than were male figures. One theory is that this may reflect the striving of Buddhist laypeople and monks to abandon attachment, including attachment to physical beauty. But such figures were not merely intended to represent that which must be transcended; the prominent amulets they wear suggest that they may also have been protective figures.

The tattoos on the face of this goddess may be further indications of the figure's ability to shield people from harmful powers: on each cheek is an elephant goad, likely a protective symbol. However, the tattoos may also represent the mental discipline needed to control desire and attachment. The goddess's beautiful body could be a warning to monks and nuns about the dangers of desire, aiding them on the path to liberation. This complex role is played only by women, not by men.

Sandstone
28 x 30.5 x 15.2 cm (11 x 12 x 6 in.)
Denman Waldo Ross Collection 31.435

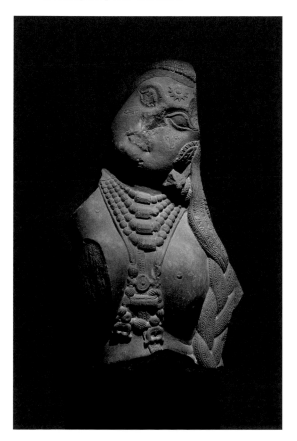

Bodhisattva Avalokiteshvara
8th century CE
Sri Lanka

While this figure's graceful and slender body is not designed to convey physical strength, the smooth chest and broad shoulders signal that it is male. By virtue of the seated Buddha figure on his headdress, we can identify him as Avalokiteshvara, among the most important of the Mahayana Buddhist figures known as bodhisattvas, who choose to follow the path toward enlightenment so that all beings may be liberated from the cycle of birth, death, and rebirth. Avalokiteshvara is considered male in Sanskrit texts on Buddhism from India, but came to be viewed mainly as female in China for reasons that are not entirely clear.

Worship of Avalokiteshvara is an important part of the practice of Mahayana Buddhism, a major form of the religion that arose in the early centuries CE and is today the most prevalent form of Buddhism across Asia. Mahayana took root in Sri Lanka by the eighth century. There, Avalokiteshvara was venerated as one who could rescue sentient beings from the suffering conditions of earthly life as well as from continued rebirth. If this tiny sculpture, one of the earliest surviving Sri Lankan images of Avalokiteshvara, depicts the bodhisattva as a lithe figure who seems unlikely to have the strength to rescue and protect anyone physically, that is entirely in keeping with Sri Lankan belief at the time. Avalokiteshvara's power, in this context, was understood as deriving from his asceticism and his compassion. His ability to rescue or protect lies, therefore, in his wisdom rather than in his physical stature, and this is reflected in his serene bearing and his pose (*rajalilasana*), the "posture of royal ease."

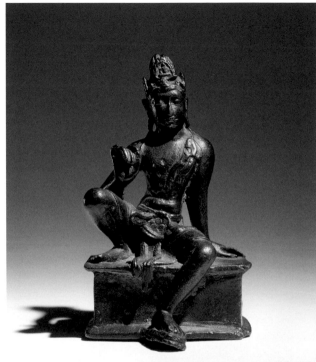

Bronze
Height: 15.2 cm (6 in.)
Ross-Coomaraswamy Collection 17.2312

Bodhisattva Avalokiteshvara

mid-10th century

Bodhgaya region, Bihar, India

This image of Avalokiteshvara, which probably once flanked a larger image of the Buddha in a Buddhist monastery, along with a matching image of the bodhisattva Maitreya, is among the most beautiful works of South Asian Buddhist art. Avalokiteshvara's serpentine pose and the extreme fluidity of the lotus stem that trails over his left hand give this sculpture an animate quality that is powerfully affecting, despite his serene expression.

His body is slender, an ideal form that directly reflects the reality of neither male bodies nor female bodies. This idealized form was, in early Buddhist texts, sometimes contrasted with the female body. These sources treat the bodhisattva body as utterly decorous and composed, overcoming and transcending the constraints of the human body, while the female body is impure and impermanent, fundamentally physical.

Gray schist
77.3 x 39 x 25.4 cm (30⅜ x 15⅜ x 10 in.)
Marshall H. Gould Fund and Frederick L. Jack Fund
63.418

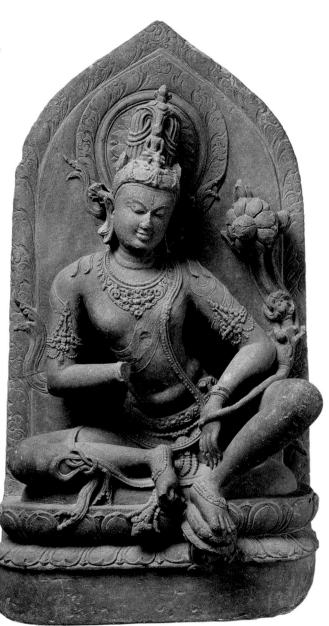

Vajrabhairava with his consort Vajravetali, 17th century
Tibet

Vajrabhairava is known in Tibetan Buddhism as a *yidam*, a tutelary deity that devotees visualize during particular forms of meditation rituals. As such, Vajrabhairava embodies a system of instruction for taking a particular path to enlightenment. The goal of this journey is given material form in this sculpture of Vajrabhairava joined in sexual union with his consort, Vajravetali. The intense meditative visualizations required by this system harness the energies of terror and anger to defeat ego, attachment, and the specter of death. Vajrabhairava's primary head is that of a raging buffalo, and he wears a necklace of severed heads. His thirty-four arms hold ritual implements including a curved knife, bell, thunderbolt, and skull-cup.

While a sexual encounter may be an expression of love or desire for an ordinary person, for a Tantric practitioner it is an act that catalyzes profound transformation. Vajrabhairava towers over the smaller body of his consort, which is endowed with just two arms and a single head. He may be physically larger, but nevertheless he needs her: she represents half of the metaphysical union that their embrace stands for, the union of *karuna* (compassion, associated with the male) and *prajna* (wisdom, associated with the female). Only when wisdom has been attained can compassion be applied.

When a practitioner meditates on an image like this sculpture, the aim is not to identify solely with either the male or the female, but rather to attain the bliss of nonduality through identification with both figures, in union.

Copper and brass, partially silvered and gilt, with pigment and inlaid semiprecious gems
55.2 x 43.2 x 22.9 cm (21¾ x 17 x 9 in.)
William Sturgis Bigelow Collection 21.2168

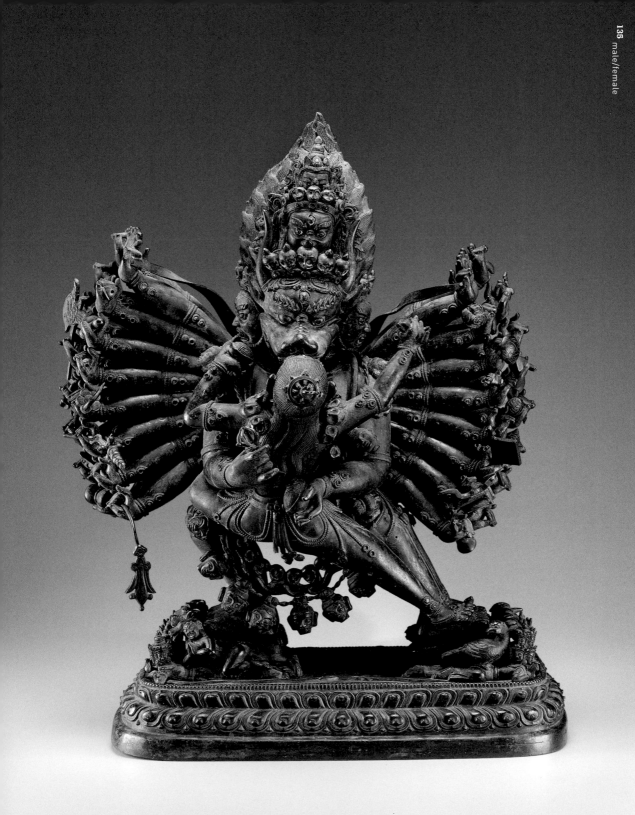

Bhim Singh of Jodhpur, late 18th century
Ascribed to Budh Lal (active late 18th century, Indian)
Kishangarh, Rajasthan, India

The leaders of the Rajput kingdoms of northern India were expected to be accomplished warriors, as well as being physically attractive and richly adorned. In this portrait, the ruler Bhim Singh of Jodhpur (r. 1793–1803) seems to meet all these criteria.

Bhim Singh's efficacy on the field of battle is conveyed by the black and gold shield that he holds in front of his kneeling body. He is also undeniably beautiful. His body is mostly obscured but drawn in gentle curves; his legs appear to be broad and strong, reminiscent of literary descriptions of a ruler's thighs being like ruby pillars or sandal trees. A fantastic halo adds glamour to the image, an effect matched by his luxurious garments and accessories: a translucent white and gold *jama* over pink underclothes, with an ornate sash and jeweled belt, three pearl necklaces embellished with rubies and emeralds, and a range of other jewels including large pearl earrings. Jewelry like this was commonly worn by Rajput males as well as females. Both sexes dressed according to similar conventions, rooted in an ancient belief that the beauty of each could be enhanced by ornament (*alankara*).

Bhim Singh rests in a pleasure palace in Kishangarh, identifiable by the characteristic landscape in the background. He would have gone to such a place to enjoy cool breezes; the company of friends, wives, and lovers; and music, dance, food, wine, and other mild intoxicants. He sits, presumably enjoying the view or waiting for companions, on a carpeted terrace with a low railing, beyond which is a flower garden and a lake rimmed with palaces. Pillows made of intricate textiles, a jade bowl, and a jeweled box lie nearby, suggesting the opportunity to enjoy repose, snacks, and beautiful objects.

Opaque watercolor and gold on paper
31.7 x 21.9 cm (12½ x 8⅝ in.)
Gift of John Goelet 66.136

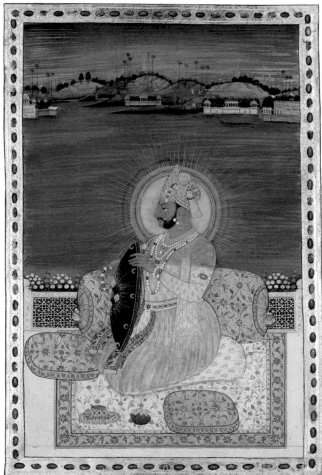

A gathering, about 1660
Possibly Deccan region, India

Pleasure is the subject of this painting, as in
the portrait of Bhim Singh, though here we see
women enjoying one another's company. This
painting in the Mughal style has at times been
taken as evidence that those who lived in the
women's quarters of a Mughal or Rajput palace
resorted to lesbianism because they lacked
male company. In fact, this image probably says
more about the imagination of male artists than
it does about the actual lives of women in the
royal court.

Here the artist has conjured an image of a
group of women of various ages who have been
drinking together, evident from the many wine
cups and bottles. The way they lean on, hold,
and touch one another suggests an intimate
and pleasure-filled atmosphere. The brightly
colored and ornamented bands at the front
of the women's skirts seem to cascade down
from their bodies to pool in the central space
between them, amplifying a sense that pent-up
desires are being released.

Scenes like this were popular among Mughal
and Rajput courtiers of the seventeenth and eigh-
teenth centuries, perhaps because of the semierotic
content and the voyeuristic pleasure of looking upon
a gathering they would be forbidden to enter in real-
ity. However, these women are shown not only as
erotic objects but also as individuals with their own
desires and pleasures. The two central figures are so
intent on each other that they seem to have forgot-
ten the wine cup they jointly hold. The bond between
them is restricted to the tight circle of their gazes,
leaving viewers decidedly out of the loop. An inscrip-
tion on the back identifies the scene as depicting a
gathering with *do pyari* (two lovers).

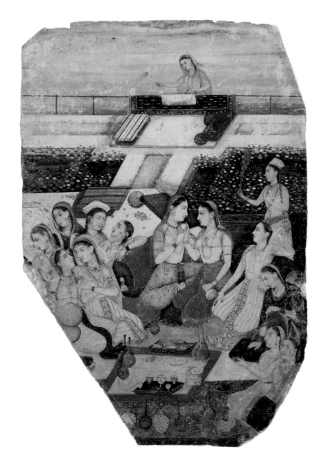

Opaque watercolor and gold on paper
23.5 x 15.8 cm (9¼ x 6¼ in.)
Gift of John Goelet 66.149

Malava Ragaputra, about 1760
Bundi, Rajasthan, India

South Asian texts on romantic experience, which were extremely popular in the period when this painting was made, describe women in a range of moods and circumstances, from eager affection to abject sorrow to jealous rage. While these texts were primarily aimed at and written by men, the roles assigned to women are not entirely submissive and sexual, but neither are they entirely the opposite. Here we see Radha as a diminutive yet affectionate and willing partner to her divine lover, the Hindu god Krishna (an incarnation of Vishnu). She and Krishna stride across a courtyard toward a bedroom, nose to nose and utterly intent on their connection, neither of them looking where they are going.

Radha is among the most prominent archetypes of womanhood in South Asia. Although here she is depicted in the clothing of a Rajput princess, in myth and literature she is a *gopi*, a milkmaid. According to Hindu tradition, during his youth, Krishna often played and flirted with the *gopi*s, and Radha eventually became his favorite and his primary lover, despite the fact that she was married to someone else. So powerful is the tale of Krishna and Radha that she is worshipped in South Asia as a goddess, an avatar of Lakshmi. Although Radha is nearly always depicted in the context of her relationship with Krishna, she is not completely submissive to him either. She is loving but stubborn, refusing to give in when he seems to have abandoned her. In some texts, she is the dominant one in their relationship.

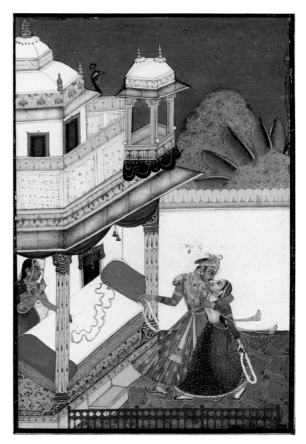

Opaque watercolor, gold, and silver on paper
34 x 24 cm (13 3/8 x 9 1/2 in.)
Gift of John Goelet 67.800

Krishna awaiting Radha, probably 1629
Page from a *Gita Govinda* series
Mewar, Rajasthan, India

Radha and Krishna are about to reunite after a pro-
longed separation in this painting of an episode from
the *Gita Govinda*, a famed twelfth-century Sanskrit
poem about the two great lovers. Seated in a grove of
trees at the bottom of the painting, Krishna eagerly
prepares a bed of flowers to lie down in with Radha,
if and when she arrives. His desperation for her can
be read in his pose: while he prepares the bed, he
turns his head so that he will not miss a glimpse of
her coming down the hill. As the lines of prose along
the top of the page say, he is wasting away, awaiting
her like a vine that is ready to wrap itself around
what it desires.

The two images of Radha at the top of the paint-
ing convey a complementary set of feelings. In the
upper left, she sits inside a forest bower, unsure
whether to give in to a friend who urges her to go to
Krishna, who is languishing in her absence. In the
upper right, the friend leads Radha over the hill. The
text tells us that she is weeping but goes quickly
toward Krishna. Looking at this painting or one like
it, both male and female followers of Krishna would
identify with Radha since she is the model human
devotee, one who gives up everything for God. To
identify aspects of Radha within oneself is an aim of
Krishna worship.

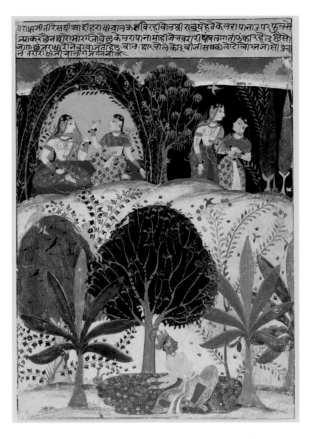

Opaque watercolor and gold on paper
26.3 x 18.6 cm (10 3/8 x 7 3/8 in.)
Denman Waldo Ross Collection 32.53

Krishna, about 1780–1800
Attributed to Sahib Ram (1750–1820, Indian)
Court of Jaipur, Rajasthan, India

This drawing is probably a representation of the Hindu god Krishna, whose playful dancing with the *gopi*s (milkmaids) on moonlit nights has been a favorite subject of South Asia's artists, dancers, and authors. This and a number of related drawings are probably studies or patterns for a large painting made for the Rajput ruler Maharaja Pratap Singh of Jaipur (r. 1778–1803). Pratap Singh was an ardent devotee of Krishna; he composed poetry to the god and staged at his court elaborate performances of Krishna's legendary dance with Radha and her female companions.

Although Krishna is shown wearing a man's turban here, the long hair and jewelry suggest that the drawing actually represents a female court dancer of the eighteenth century in the guise of Krishna. It is not surprising that a female dancer would play the role of Krishna. Cross-dressing is a frequent occurrence in stories and images of the two lovers, emerging from a playful episode called *lila-hava* in which they exchange clothes. Within the context of Krishna worship, there are many such instances of gender fluidity.

Ink, wash, and opaque watercolor on paper
132.1 x 94 cm (52 x 37 in.)
Ross-Coomaraswamy Collection 17.3081

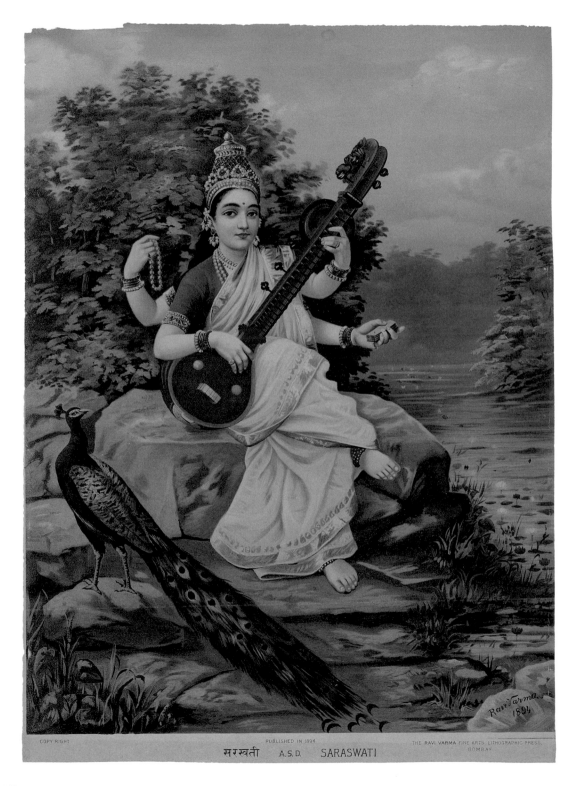

COPY RIGHT PUBLISHED IN 1894 THE RAVI VARMA FINE ARTS LITHOGRAPHIC PRESS, BOMBAY.

सरस्वती A.S.D. SARASWATI

Saraswati, 1894
Published by Ravi Varma Fine Arts Lithographic Press
Distributed by Anant Shivaji Desai
Mumbai, Maharashtra, India

The ideal of Indian womanhood was a topic of major debate
and concern during the colonial era. Among nationalists who
sought independence, the woman became a symbol of the
nation and an embodiment of its most important ideals. As
a result, images of women—whether goddesses or human
beings—underwent major shifts during this period.

One figure who played a major role in this evolution was
the painter Raja Ravi Varma (1848–1906), who in the latter
half of the nineteenth century depicted South Asian women
(both those of myth and literature and those of his own time)
in oil on canvas using Western perspective and naturalistic
color. The press he founded in 1892 used the newly arrived
technology of lithography to disseminate reproductions of his
paintings, particularly those of goddesses, across the subcon-
tinent. These low-cost images soon appeared everywhere, and
although he quickly sold his press, it went on to make a last-
ing impact on the visual culture of South Asia.

This is one of Varma's most indelible images: the goddess
Saraswati, seated on a rock by a river, playing her tambura
and accompanied by her peacock mount. She represents a
conjunction of tradition and modernity: though she has four
arms, in every other feature she is an ordinary upper-class
Hindu woman of the 1890s. She is light-skinned with a pleas-
ingly plump figure, and she wears a beautiful sari and gold
jewelry. Her mythic identity stands for the depth and power
of a culture that goes back millennia, while her realistic mode
of depiction and the mechanical technique of her produc-
tion mark her as modern. She has become the ideal national
female.

Lithograph
71.1 x 50.8 cm (28 x 20 in.)
Gift of Mark Baron and Elise Boisanté 2017.3969

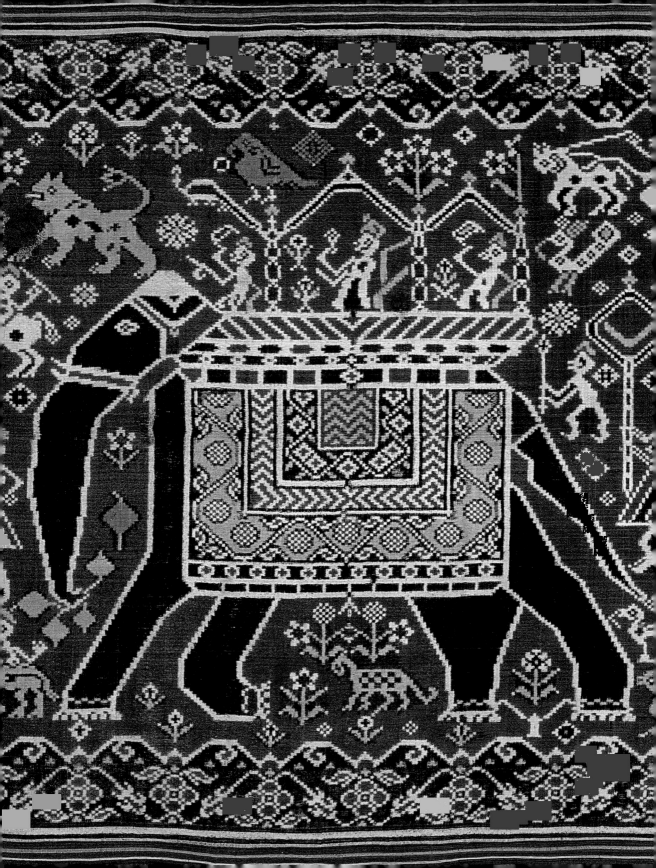

Local/Foreign

South Asian art has unique features that distinguish it from the art of other regions, but many of its most distinctive and remarkable forms could never have arisen without prolonged and intense cultural exchange with outside peoples and places. Given that this cultural exchange began as early as the Indus Valley Civilization (2600 BCE–1700 BCE), it is questionable whether any arts of South Asia can be considered to have emerged in a space insulated from all external cultures. For these reasons, framing the region's art as either local or foreign is deceptive.

During the colonial period, however, this was often how the arts of South Asia were viewed. One frequently made assertion in the nineteenth century was that South Asia was essentially static in its culture and social structure. Any cultural practice or tradition that appeared to have progressed or advanced was therefore deemed foreign. For example, the innovation within Buddhist art that led to sculptures of the seated Buddha—so iconic in the world today—was at one time considered by European scholars to have been made possible only through cultural exchange with the Hellenistic empire of Alexander the Great.

Nationalists, meanwhile, felt that too many of South Asia's great artistic and cultural accomplishments were being attributed to the influence of supposedly superior outside societies. Scholars with this inclination dedicated a great amount of energy to arguing that the region's arts had merit apart from any foreign influence and identifying certain strands of art as pristine, uncontaminated by outside cultures. Some found evidence in Sanskrit treatises containing ancient indigenous bodies of aesthetic knowledge; others focused on the archaeology of pre-Islamic art from South Asia, seeing in it the most truly "authentic" form of the region's artistic culture. Such efforts to define the essential nature of the region's culture were part of larger orientalist and nationalist dialogues, which at times became colored by race theories, as some argued that the best and purest arts were the product of the strongest and purest race. Even today this

topic continues to be hotly debated and divisive, particularly when it is used to assert that some people belong in South Asia whereas others do not.

Setting aside the question of who or what is truly indigenous to South Asia opens the way for more productive investigations of South Asian art: What forms of art and culture are found only in this region? What forms emerged through particularly fruitful exchanges with a culture beyond South Asia? Why do some forms of art appear all across South Asia while others are local to a single area within the region? What types of representations of "outsiders" or "foreigners" can be found within South Asian art, and what do these tell us about identity, community, and notions of difference at various times and places?

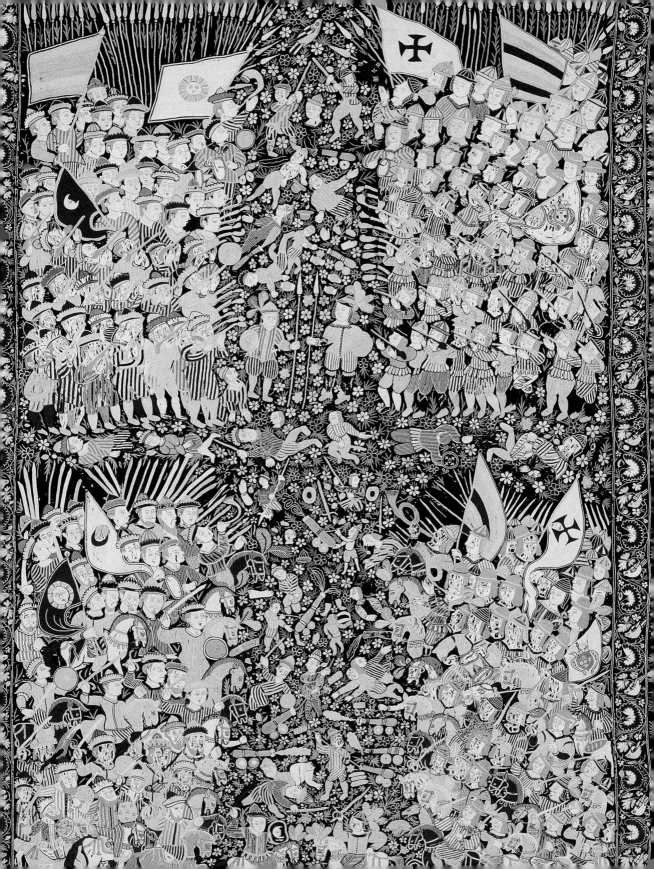

Bodhisattva Maitreya, 3rd century CE

Northwest Pakistan

From the thick folds of his robe to the taut musculature of his abdomen, this sculpture proclaims its connection to the Hellenistic world of Alexander the Great's empire. It comes from an area of Pakistan's Peshawar valley once known as Gandhara, which was taken by the great conqueror in 327 BCE. For centuries afterward, Gandhara was part of kingdoms whose cultures were strongly Greek, in part through trade by sea that connected the region to the Mediterranean. But because Gandhara was also connected to the Indo-Gangetic plain to the south, the art forms that emerged there are often described as Indo-Hellenic.

When it was acquired by the Museum of Fine Arts, Boston, in 1937, Ananda K. Coomaraswamy, the curator who proposed the purchase of this sculpture of Maitreya, stated that, personally, he did not "as a rule care for this kind of sculpture." A strong believer that the Westernization caused by eighteenth- and nineteenth-century British colonialization threatened India's ancient arts and culture, he saw Gandharan sculpture as evidence of an earlier period in which outside influences had adulterated South Asian culture. Fortunately, he realized that this well-preserved and imposing sculpture had value nevertheless.

Maitreya is a bodhisattva who, it is believed, will be born in the future at a time when the world no longer remembers the historical Buddha. In this image, he is a princely figure, with a moustache and curling hair tied on the top of his head in a Greek manner and wearing a wide array of jewels and a number of Buddhist amulet boxes. His hands are lost, but one was probably raised in the gesture of reassurance while the other, at waist level, held a water bottle, an emblem marking him as Maitreya.

Gray schist

109.5 x 38.1 x 22.9 cm (43⅛ x 15 x 9 in.)

Helen and Alice Colburn Fund 37.99

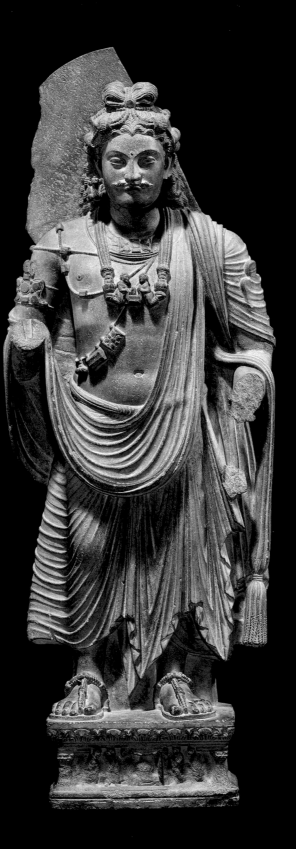

Buddha, late 1st–early 2nd century CE
Mathura, Uttar Pradesh, India

The rulers of the Kushan empire (about second century BCE to third century CE), who sponsored the construction of many Buddhist monuments in Gandhara, also erected monuments farther south. There, the buildings and sculptures were made of local materials and possessed quite distinct features. This sculpture of the Buddha is carved of stone from the state of Uttar Pradesh, in the southern reaches of Kushan territory. It depicts a monk-like rather than a princely Buddhist figure. The Buddha, the historical Shakyamuni, is depicted here seated under a bodhi tree wearing the simple robe that marks him as one following the renunciant's path. He sits in *padma-sana* (lotus position), with both heels turned up and incised with Buddhist symbols. To his right is a fragmentary image that may be the god Vajrapani, with a lion skin tied around his neck and a thunderbolt in his hand. On the left is a figure carrying a fly whisk.

Here, however, we see none of the Hellenizing features of the sculpture of Maitreya, nor the thick and naturalistic folding of the robe or the Greek hairstyle and tautly muscular body. The style is instead rooted in a sculptural tradition local to the region around the northern Indian city of Mathura. There, native red sandstone was used to make images of full-bodied pre-Buddhist nature spirits—female *yakshi*s and male *yaksha*s—whose thin robes exposed their bodies to viewer's eyes. Such sculptures seem to have provided the model for Mathura's images of the Buddha.

Buddhist sculptures from Mathura like this one came to be admired in the early twentieth century by art historians who sought to defend South Asian art against the charge of influence by foreign cultures. These depictions of the Buddha were cast as more authentically South Asian than others because they contained no elements borrowed from the arts of Greece and Rome.

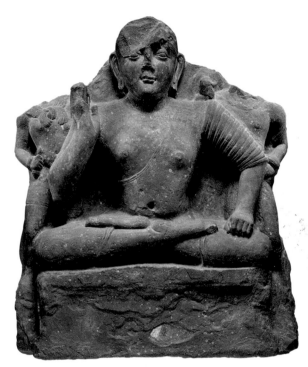

Sandstone
50.8 x 56.2 cm (20 x 22⅛ in.)
David Pulsifer Kimball Fund 25.437

Melancholic woman, painting about 1590–95,
folio and borders about 1600–18
Attributed to Basawan (active 1565–1598, Indian)
Page from the *Gulshan Album*
Northern India

Beginning in the late sixteenth century, artists
working at the Mughal court began to incorporate
ideas from European paintings and prints into
their work. They had access to European wood-
cuts, engravings, and printed books through a
series of Jesuit missions that were welcomed by
the Mughal emperors Akbar and Jahangir. Local
artists exposed to these objects sometimes simply
copied European imagery using locally available
materials and techniques; at other times assimi-
lated into their work elements they found intrigu-
ing or useful. In this painting of a woman sitting
in a palace garden, the artist has used European
naturalistic techniques to make the central figure
monumental in both body and mood.

It is not only technique that this artist has
borrowed from European sources but genre as
well. Allegory was popular in imperial Mughal
painting in the early years of the seventeenth
century, and Mughal texts of the time attest that
artists admired and emulated the way European
allegorical and symbolic images gave visual form to
abstract concepts and ideas. The allegorical figure
Melancholia was a common subject in sixteenth-
century European engravings, and the woman in
this Mughal painting clearly derives from such an
image. European depictions generally feature a figure
who sits in a slumped posture, resting her head in
one hand, surrounded by unused objects of science,
craft, and art. Here the Mughal woman sits on a mas-
sive plinth, head resting against her left arm, in a
courtyard strewn with objects that are mostly items
used for Christian ritual (probably reflecting items
brought to India by missionaries).

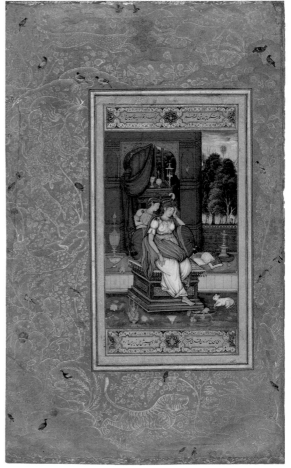

In this painting, both the notion of the allegorical
image and the specific iconography are almost com-
pletely European, but many other Mughal allegorical
works bring together iconography that is drawn from
Central Asia, India, Persia, the ancient Near East, and
other sources.

Opaque watercolor and gold on paper
42.6 x 26.2 cm (16¾ x 10⅜ in.)
Bartlett Collection—Museum purchase with funds from the
Francis Bartlett Donation of 1912 and Picture Fund 14.688

Dara Shikoh and his consort, about 1635
Attributed to Balchand (active about 1595–1650, Indian)
Northern India

By the time this painting was made, European techniques had become very much assimilated into Mughal painting. Here we can see one of the masters of the Mughal atelier, Balchand, using them to great effect and in a way that is seamlessly integrated into the painting. Balchand would not have been the only artist to work on this painting. He may have been responsible for the composition and perhaps the faces or finishing touches, but landscape and architectural features could have been done by another artist. In the Mughal workshop, artists of different cultural, social, and religious backgrounds worked together on paintings under the supervision of a workshop head.

At the center of this image is a royal couple enjoying a romantic idyll on a lakeside terrace. The trees on the far shore are rendered smaller and less distinct than the one in the foreground that offers the couple some shade, creating a convincing illusion of spatial recession. The scene is composed in mild and natural-looking colors, mimicking optical reality, and the figures are scaled and detailed so as to convey their materiality and individuality.

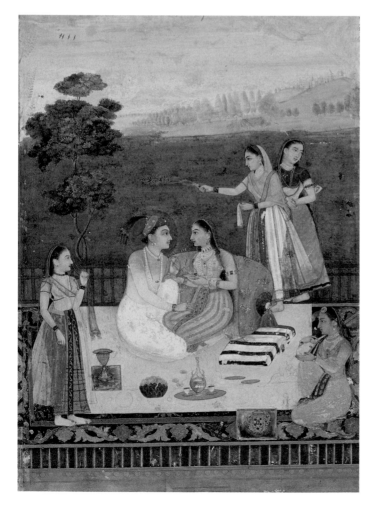

A halo around the head of one of the two central figures suggests that this is, however, more than simply a genre painting of a couple enjoying themselves by a lake. The male figure is Dara Shikoh, son of the Mughal emperor Shah Jahan. He sits gazing intensely at a woman who is surely his wife. Indeed, the painting may have been made near the time of the wedding to commemorate their union. A very similar painting of Dara's younger brother Shuja and his consort was perhaps also made as a wedding portrait.

Opaque watercolor on paper
22.8 x 14.3 cm (9 x 5⅝ in.)
Special Fund for the purchase of Indian Art
13.1402

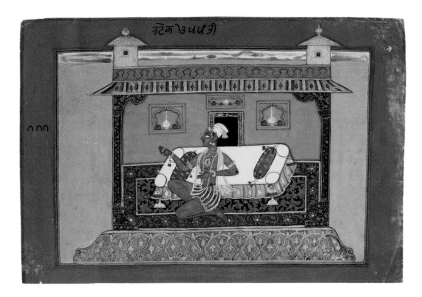

Hero Pining for Another Man's Wife

about 1660–70

Attributed to Kripal (active about 1660–1690, Indian)
Page from a Rasamanjari series
Basohli or Nurpur, Punjab Hills, India

Though made not long after the painting of Dara Shikoh, this image shows little or no Westernizing features. The artist, Kripal of Nurpur, rejects natural-looking colors for a bold palette and makes no attempt to convey spatial recession, creating an intensely vibrant and narratively condensed image.

While the Mughal royal workshop was filled with artists of different backgrounds, there is little evidence of this in the Punjab Hills region where Kripal lived and worked. There, paintings were made within families of artists who did not necessarily even live in the capital of the kingdom or nearby. The style of the painting depended on which family made the work. Kripal was the head of such a family workshop. His son and grandson also became painters.

This painting belongs to one of Kripal's most renowned works, a series of illustrations of Bhanudatta's *Rasamanjari*, a fifteenth-century Sanskrit text that describes a range of different but uniformly intense romantic experiences, many outside the bounds of ordinary courtship or marital relations. Here we see a man inside his house, sitting by his bed, desperate to see and be with the woman he admires, though she is the wife of another man. His blue skin indicates that he is actually the god Krishna, linking this episode with Krishna's legendary pursuit of Radha. The painting's incandescent colors reflect the potency of the hero's romantic torment.

The Sanskrit language dominated South Asian literature from about 500 to 1500. It was the source of a translocal literary culture that can be seen in works of literature written across South Asia, in inscriptions on temples and royal proclamations, and in religious rituals. To write in Sanskrit or illustrate a Sanskrit text was, therefore, to express membership in a world larger than one's own hometown or kingdom. At the same time, artists who illustrated Sanskrit texts generally used the pictorial style that was most popular in their family, court, or region, making these works at once strongly local and more broadly regional.

Opaque watercolor, silver, gold, and beetle wing on paper
21.8 x 31.7 cm (8⅝ x 12½ in.)
Ross-Coomaraswamy Collection 17.2784

Seal impression, 5th century CE
Northern India

In the center of this small impression from an ancient clay seal is an image of a bird standing behind a woman who has one arm raised high as if grasping the bird's wing or fending the creature off. The bird is not a normal avian creature; it towers over the woman. There are few other details to help us identify what story is being alluded to here, simply because the object is so small. More clues can be found in the similar imagery of surviving sculptures and reliefs from Buddhist sites and monuments in the Gandhara region. These works, made between the third and fifth centuries CE, are generally interpreted as depicting the abduction of a *nagi*, a female snake divinity, by a legendary bird from South Asian myth known as Garuda. Given its Buddhist context, Garuda's drive to possess the *nagi* seems to be used here to symbolize the Buddha's teaching of the importance of renouncing desire.

The earliest traces of this imagery are, however, found far outside of South Asia. In fact, the motif of a massive bird seizing a human being can be found in art from many different ancient cultures. Greek and Roman images, for example, relate the tale of Ganymede, a beautiful human man who was abducted by Zeus in the form of an eagle. It is thought that this story gave rise to the Gandharan works of art.

A tiny inscription, written in a Northern form of the script associated with the Gupta empire, appears to the right of the image of bird and woman on this seal impression: "of Bhima." The seal was probably owned by a man named Bhima who lived in northern India and used it to label his parcels—grooves made by strings tied around the parcel are still visible on the back of the object. Perhaps Bhima chose this ancient mythological story for his seal because of its Buddhist meanings or its sheer longevity, or perhaps for some entirely different personal meaning.

Clay
3.6 x 3 x 1.5 cm (1 3/8 x 1 1/8 x 5/8 in.)
Louis Curtis Fund 36.622

Mural fragment, late 5th century CE
Ajanta, Maharashtra, India

The vast and beautiful Buddhist site of Ajanta contains a large group of monasteries and temples cut into a rocky cliff in the Western Ghats, a mountain range that runs parallel to the western coast of India. The practice of carving temples out of mountains began in India by the third century BCE and then spread, with Buddhism, to Central Asia, Southeast Asia, and China. Many regions of South Asia are home to Buddhist and Hindu cave temples built in different periods.

While cave temples belong both to South Asian art and to Asian art more generally, Ajanta's murals are unique. This fragment, the only piece of the Ajanta murals known to exist outside the site itself, comes from a wall of Cave 16 that depicts the tale of how the Buddha's half-brother, Nanda, became a monk. At the bottom, in a black cap, is Nanda's servant, wrestling with a monk who is about to shave Nanda's head and thereby initiate him. According to the tale, Nanda was uncertain about whether he wanted to forgo his life and family for the monastic path, but ultimately the Buddha was able to convince him by explaining that through that path he could attain something far greater than love and luxury.

The paintings at Ajanta, some of the earliest extant paintings from India, were made by skilled artists who worked at the site and painted in styles that developed quickly under the pressure of eager and diverse patrons. Cave 16 is one of the most impressive in its paintings, a reflection of its patron's wealth and support for the site. An inscription on its veranda tells us that the cave was sponsored by Varahadeva, a minister of the Vakataka king Harishena (r. 460–78 CE), Ajanta's most important donor.

Opaque watercolor on plaster
38 x 26 cm (15 x 10¼ in.)
Clara Bertram Kimball Fund 21.1286

Arch façade, late 17th century
Northern India

Like the mural fragment, this ornamental façade of an arched gateway represents a strand of South Asian art that belongs to a broader tradition that extends beyond just this one region—in this case, the tradition of Islamic architecture. A large yet fragmentary piece of Mughal architecture, the arch is Islamic in the sense that the Mughals drew architectural ideas and talent from the Islamic lands to the west, particularly Iran and Central Asia, the heartland of their forebears. At the same time, it reflects the many cultures and artistic traditions that came together in Mughal architecture. We can reasonably surmise that it was made by South Asian builders and stone carvers using the local red sandstone, perhaps under the supervision of Persian and Turkic architects whose style and designs were rooted in architecture of the eastern Islamic world.

The building or complex to which this arch façade originally belonged is not known, but since the façade is made up of several relatively thin panels of sandstone, it is likely that it was used as a facing on a structure of brick and rubble construction. The panels are carved in floral designs of two distinct types: a repeating and relatively simple design on the outer border and a looser, more naturalistic pattern in the spandrels. While the outer pattern reflects Mughal architecture's connection to Islamic art in general, with its emphasis on abstracted plant motifs, the spandrels' realistic imagery comes out of Mughal engagement with European art and especially with European methods of depicting and documenting the natural world.

Sandstone
304.8 x 304.8 cm (120 x 120 in.)
Keith McLeod Fund 1983.386

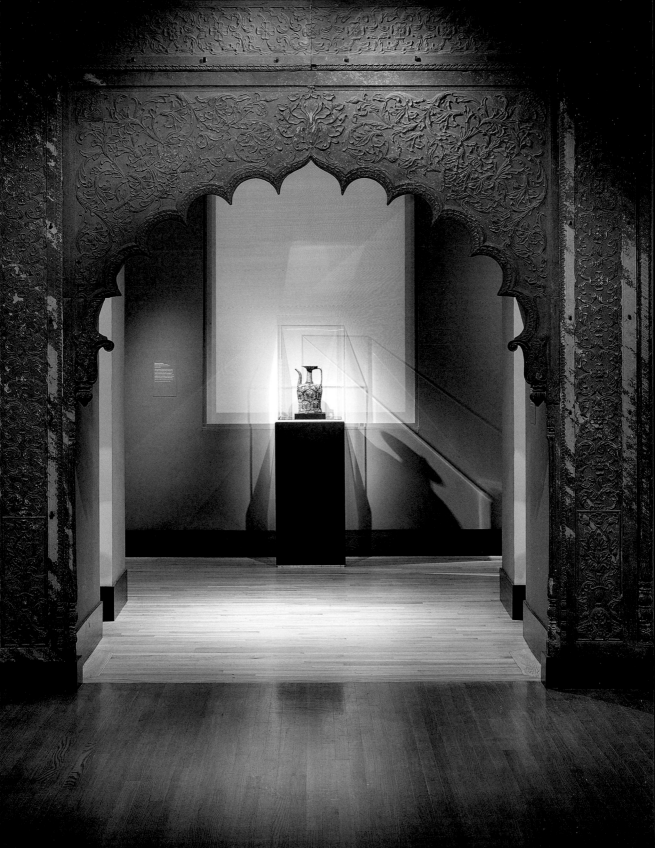

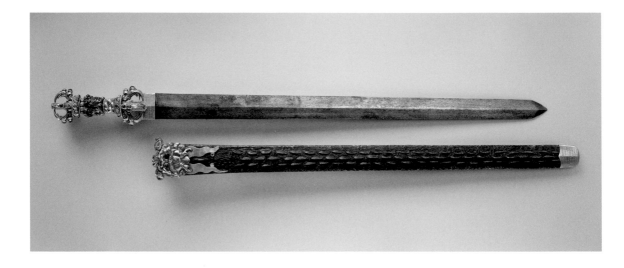

Ritual sword and scabbard, early 14th century
Tibet or China

This ritual sword is thought to have been made at the Ming imperial court in China as a gift for a Buddhist temple in Tibet. Tibetan Buddhism had begun to have a powerful impact on Chinese Buddhism around the thirteenth century, and its lamas played a key role in converting the Yuan dynasty's Mongols to Buddhism and establishing diplomatic relations between Tibet and China. Naturally, these types of relationships led to artistic exchange. Records tell of Tibetan artists being sent to train artists in China's imperial workshops and of Chinese artists working in Tibet. A number of extremely beautiful Tibetan Buddhist ritual objects are known to have been commissioned by Ming emperors, perhaps for use at court or as diplomatic gifts to a high-ranking Tibetan spiritual leader. This may be such an object.

A ritual sword is used to symbolically cut down or destroy ignorance. This masterful example combines Chinese workmanship with Tibetan imagery. The hilt is formed of an ornate *vajra*, or thunderbolt, with three wrathful faces and inlays of coral and lapis. On the top of the blade and on the gold endpiece of the scabbard are inscribed Buddhist mantras in Sanskrit, written in the Newari script that is found in Nepal.

Cast-iron blade with crocodile-skin-covered scabbard, both decorated in gold, silver, and iron as well as coral, glass, and lapis lazuli
Sword: 7.5 x 92 cm (3 x 36¼ in.)
Scabbard: 8 x 78 cm (3⅛ x 30¾ in.)
Frederick L. Jack Fund and funds donated anonymously
1988.326a–b

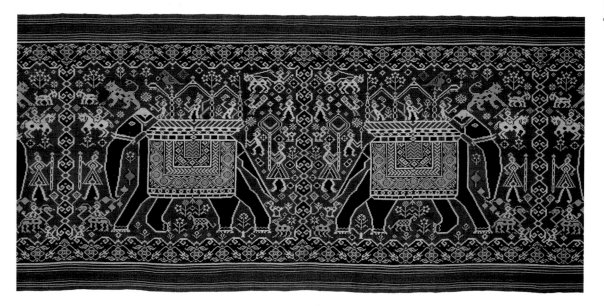

Ceremonial hanging (*patolu*), late 18th century
Gujarat, India

Patola are an immensely complex and beautiful type of South Asian textile made in the region of India that is today called Gujarat. This elephant-patterned *patolu* was found far from there, however, in eastern Indonesia. It was probably transported by Dutch merchants to be given to an Indonesian ruler as a mark of special esteem, something they are known to have often done. The pattern, which appears against a rich rust background, depicts a royal procession or perhaps a hunt. Large elephants bearing howdahs carrying a royal individual and two fly-whisk-holding attendants are accompanied by standard bearers, soldiers, and a range of animals.

The Indonesian recipient of this *patolu* would have been well aware that it was made using one of the most expensive and difficult weaving techniques known from the whole of South and Southeast Asia—double ikat, in which warp and weft threads are dyed in the precise design required before they are woven together on a loom. Profound expertise would have been needed to achieve this complex imagery.

While *patola* were used in South Asia as wedding saris and for other luxury garments, these items do not enjoy the same excellent preservation as those made for the Indonesian market. *Patola* like this one, made specifically for export to Indonesia, were used for religious and ceremonial functions and were often preserved as family heirlooms.

Silk plain-weave and gold-wrapped thread; warp and weft resist-dyed (double ikat)
109.2 x 485.1 cm (43 x 191 in.)
Marshall H. Gould Fund 1985.709

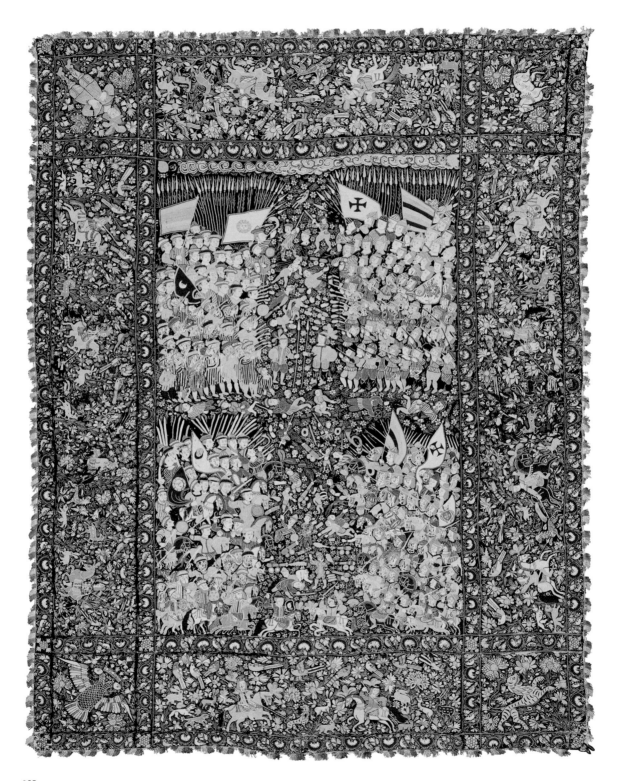

Embroidered cover or hanging, 17th century
Gujarat, India

A crowded battle scene occupies the central area of this textile, made in Gujarat for the Portuguese market. In the upper part, a battle of foot soldiers rages, while in the lower half horsemen charge toward one another. In the space between the two armies lie dead soldiers, some missing limbs. Two flags on the right side bear a red cross that was the emblem of the Portuguese Military Order of Christ, indicating that the scene may commemorate a military event in which the Portuguese triumphed.

Given the specific nature of the imagery, this embroidered cover must have been made for a Portuguese client. The Portuguese were the first to import embroideries from Gujarat for the Western European market, the appetite for which was at its height in the seventeenth century. Many of these embroideries combine European imagery with South Asian and Persian motifs, but here the dominance of Portuguese and Habsburg imagery and symbols—for example, the double-headed eagle in the lower left—demonstrates that Gujarati artists, as well as producing work with local motifs, could work in an entirely different cultural mode if required by their clients.

Silk satin embroidered with silk in chain stitch
264 x 202 cm (103⅞ x 79½ in.)
The Elizabeth Day McCormick Collection 50.3224

Bureau-cabinet, 1740–50

Vizagapatam, Andhra Pradesh, India

From at least the seventeenth century, craftsmen in the port city of Vizagapatam on the eastern coast of India produced furniture that combined European and South Asian features to appeal to both Europeans and wealthy South Asians. To either group, such objects must have seemed exotic.

The form of this bureau-cabinet is derived from early-eighteenth-century English prototypes. The lower part (the bureau) functions as a desk when open and has compartments and drawers that could be used to store papers and writing materials. The upper part (the cabinet) is composed of drawers, compartments, and shelves. It would have been easily accommodated within the home of a wealthy European merchant or official. Indeed, among the few other, similar cabinets that are known, one was made for a Dutch merchant who was an East India Company employee, and another belonged to an Englishman who served as governor of Fort St. George in Madras (now Chennai).

A riot of pattern and richness of color characterize the bureau-cabinet's ornamentation. Ebony has been used to form the cornice and base molding, contrasting with the teak from which it is primarily constructed and the dense floral decoration in ivory that has been enhanced with engraved details. The ebullient flora, emerging from urns and inhabited by all manner of animals, is derived from imagery found in South Asian manuscripts, wall paintings, and textile designs.

Teak with ebony and ivory
243.8 x 113 x 67.3 cm (96 x 44½ x 26½ in.)
Gift of James Deering Danielson 1981.499

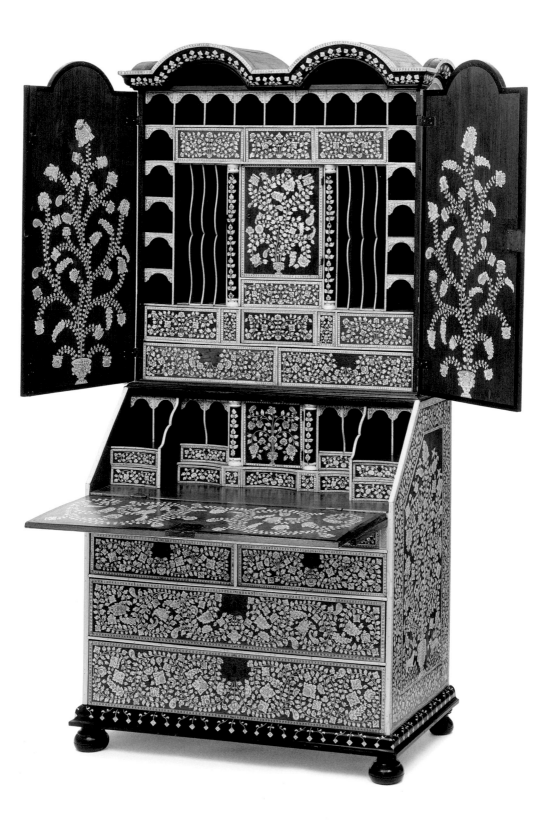

Two-handled cup, about 1880
Oomersi Mawji (active about 1860–1910, Indian)
Bhuj, Kutch District, Gujarat, India

When the nineteenth-century excavations of Pompeii brought to light a group of silver vessels of extreme beauty and delicacy, Italian and French silversmiths soon began producing souvenir reproductions for tourists. Among the objects reproduced were pairs of two-handled cups, known in Latin as *canthari*, ornamented with mythological scenes. Such cups would have been used by wealthy Pompeians at elegant dinner parties in the first century CE.

This cup, bearing the mark of the master silversmith Oomersi Mawji, is a reproduction of one of a pair of Pompeian *canthari* now in the Museo Archeologico Nazionale in Naples, Italy. The two original cups are nearly identical, each bearing images of a male and female centaur roaming a wooded landscape. Although slightly larger and heavier than the originals, this cup bears nearly identical imagery and construction.

Oomersi Mawji designed and produced exquisite silver objects from his workshop in Kutch (a district in Gujarat) from about 1860 to 1910. While his workshop created objects on order for South Asian and European markets, it also produced special pieces for his patron, the Maharao of Kutch, and it was perhaps for that ruler that the cup was made. The workshop's "O.M." mark also appears on another Italianate object: a small-scale silver copy of Michelangelo's *David*. Like many other rulers of princely states (small regional kingdoms with subsidiary alliances with the British Raj), the maharao's taste in art was eclectic and informed by European as well as South Asian trends and traditions.

Gilt silver
14 x 16.5 cm (5½ x 6½ in.)
Keith McLeod Fund and partial gift of Richard Milhender
2013.632

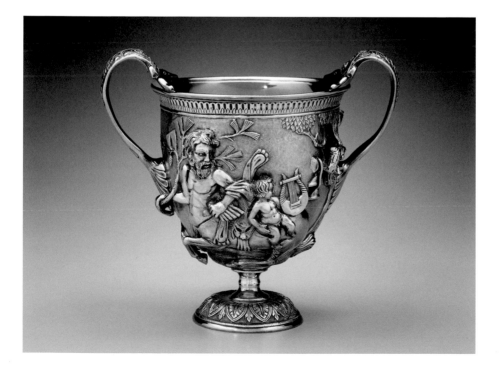

Penguin tea service, about 1930
Probably Mumbai, Maharashtra, India

South Asia's elites traveled outside the region for different reasons over the centuries. During the era of British colonialism, many went to Europe to immerse themselves in the latest trends and fashions, bringing back all manner of objects as well as altered sensibilities. A booklet entitled *List of Firms in Paris Patronised by His Highness* from the period of Ganga Singh, ruler of the Rajput kingdom of Bikaner between 1887 and 1943, shows a list of shops where that maharaja liked to purchase jewelry, furs, clocks, clothing, and other luxury items. The objects that he and other individuals brought back to India had an impact on taste and style there.

This tea service, formed of three silver emperor penguins, owes its sleek mechanistic design to art deco and was likely inspired by penguin-shaped cocktail shakers that emerged in the 1930s as a chic bar accessory. The hoods on the teapot and creamer are hinged to make it possible to pour in the desired contents, and the beaks are spouts. The torso of the sugar bowl separates entirely from its lower part to allow access to the sweetener inside.

On the left wing of each penguin is the coat of arms of Bikaner, with its shield supported by rearing tigers and a Hindi inscription reading "Jai Jangaldhar Badshah" (Victory to the King of the Desert). It is perhaps no surprise that Maharaja Ganga Singh liked to have three emperors serve him his tea. The service would have fit in well at Singh's Lallgarh Palace, which was decorated with Chinese vases, Belgian mirrors, Bohemian crystal chandeliers, and Greek sculptures.

Silver, with Bakelite handle
Height of teapot: 24.1 cm (9½ in.); height of creamer and sugar bowl: 17.8 cm (7 in.)
Keith McLeod Fund and partial gift of Richard Milhender
2013.628.1–3

Umapati Shanker, about 1945
Narottam Narayan Sharma (1896–1992, Indian)
Published by S. S. Brijbasi & Sons
Mathura, Uttar Pradesh, India

UMAPATI SHANKER

In the late seventeenth century, a *svarupa* (self-made) image of Shri Nathji, a form of the Hindu god Krishna, was installed in a temple near the Rajasthani town of Udaipur, the capital of the Rajput state of Mewar. The spot immediately became a pilgrimage site and was given the name Nathadwara (Portal of the Lord). Nathadwara soon became home to artists trained to make devotional paintings of Shri Nathji for use in temples and homes. These images are unique within South Asian painting, and their style is associated with just this one locality. In the early twentieth century, however, Nathadwara paintings became the inspiration for a new type of mass-produced Hindu devotional image that would become popular across the subcontinent.

These new images were developed by two brothers, Shrinathdasji and Syamsunderlal Brijbasi, who began their work in Karachi in the 1920s. Brijbasi prints were rooted in Nathadwara aesthetics and were based on original paintings by Nathadwara artists such as Narottam Narayan Sharma, whose painting was made into this print of Umapati Shanker (another name for Shiva). Here the god is not engaged in an episode from Hindu myth but rather holds still as if ready to be worshipped. Although the scenery is fantastical and Shiva's bluish skin color marks him as not of this world, the god's large scale within the image and his body, which appears very much like that of a normal human being, give the print a powerful sense of immediacy.

Photo-offset lithograph with varnish
50.5 x 34.6 cm (19 7/8 x 13 5/8 in.)
Marshall H. Gould Fund 2017.3967

Demonstrators, 1968

Krishna Reddy (1925–2018, Indian)

Krishna Reddy was one of many artists who, after India gained independence from Britain in 1947, sought to create a new art for the new nation. Some found inspiration within South Asian traditions while others, like Reddy, turned their attention to the modernist art being made in Europe. Given that South Asia was one of many non-Western regions mined for visual inspiration in the making of European modernism (Africa being another major source of ideas), the interest of Indian artists in this form of art represents a fascinating moment of return.

Reddy received his art training at Visva-Bharati University where, in 1947, he participated in the Quit India Movement, which demanded an end to British rule of India, by painting hundreds of posters and pasting them on walls and buildings in the dark of night. In 1949, he attended London's Slade School of Fine Art and then traveled to Paris to study at Atelier 17 under Stanley William Hayter, one of the most important Western printmakers of the twentieth century. Reddy mastered a range of innovative printmaking techniques as well as developing a personal style involving treating an intaglio plate like a sculptural object that could be deeply carved.

Demonstrators is one of several works Reddy made in response to the student demonstrations and strikes that wrought havoc in Paris in May of 1968. A row of elongated standing figures with their hands raised can be detected within the print's essentially abstract composition. With a little imagination, they can be seen as standing shoulder to shoulder in solidarity.

Engraving

33 x 43.2 cm (13 x 17 in.)

Gift of Peter and Agnes Serenyi in memory of Mrs. Emma Serenyi 2010.243

Further Reading

Adamson, Glenn. *Thinking through Craft*. New York: Berg, 2007.

Basu, Chandreyi. "Elephant Goads and Other Marks on Female Figures in Bharhut." In *Changing Forms and Cultural Identity*, edited by Deborah Klimburg-Salter and Linda Lojda, 9–11. Vol. 1 of *South Asian Archaeology and Art*. Turnhout, Belgium: Brepols, 2014.

Bean, Susan. "Craft." In *South Asian Folklore: An Encyclopaedia*, edited by Peter J. Claus, Sarah Diamond, and Margaret A. Mills, 125–27. London and New York: Routledge, 2003.

Branfoot, Crispin, ed. *Traditional Arts of South Asia: Continuity in Contemporary Practice and Patronage*. London: Saffron, 2015.

Coomaraswamy, Ananda K. *Christian and Oriental Philosophy of Art*. New York: Dover Publications, 1956.

Coomaraswamy, Ananda K. *Rajput Painting*. 2 vols. London and New York: H. Milford, Oxford University Press, 1916.

Das, Aurogeeta. "Metropolitan and Traditional: An Exploration of the Semantics in Contemporary Indian Arts Discourse." *Etnofoor* 22, no. 1 (2010): 118–35.

Dave-Mukherji, Parul. "Bodies, Power and Difference: Representations of the East-West Divide in the Comparative Study of Indian Aesthetics." *Filozofski Vestnik* 23, no. 2 (2002): 205–20.

Dehejia, Vidya. *Representing the Body: Gender Issues in Indian Art*. Delhi: Kali for Women, 1997.

Dehejia, Vidya. *Devi, the Great Goddess: Female Divinity in South Asian Art*. Exhibition catalogue. Washington, D.C.: Arthur M. Sackler Gallery; Ahmedabad: Mapin Publishing; Munich: Prestel Verlag, 1999.

Dehejia, Vidya. *Delight in Design: Indian Silver for the Raj*. Ahmedabad: Mapin Publishing, 2008.

Eaton, Richard Maxwell. *Essays on Islam and Indian History*. New Delhi and Oxford: Oxford University Press, 2000.

Gilmartin, Lawrence, David Gilmartin, and Bruce B. Lawrence. *Beyond Turk and Hindu: Rethinking Religious Identities in Islamicate South Asia*. Gainesville: University Press of Florida, 2000.

Guha-Thakurta, Tapati. *The Making of a New "Indian" Art: Artists, Aesthetics and Nationalism in Bengal, c. 1850–1920*. Cambridge: Cambridge University Press, 1992.

Havell, E. B. *Indian Sculpture and Painting*. London: J. Murray, 1908.

Havell, E. B. "Arts Administration in India." *Journal of the Royal Society of Arts* 58, no. 2985 (1910): 287.

Hawley, John Stratton, and Donna Marie Wulff. *Devi: Goddesses of India*. Berkeley: University of California Press, 1996.

Houghteling, Sylvia W. "The Emperor's Humbler Clothes: Textures of Courtly Dress in Seventeenth-Century South Asia." *Ars Orientalis* 47 (2017): 91–116.

Huntington, John C., and Dina Bangdel. *The Circle of Bliss: Buddhist Meditational Art*. Exhibition catalogue. Columbus, Ohio: Columbus Museum of Art, 2003.

Kramrisch, Stella. *The Art of India: Traditions of Indian Sculpture, Painting, and Architecture*. New York: Phaidon Publishers, 1954.

Lal, Ruby. *Empress: The Astonishing Reign of Nur Jahan*. New York: W. W. Norton & Company, 2018.

McGowan, A. S. "'All That Is Rare, Characteristic of Beautiful': Design and Defense of Tradition in Colonial India, 1851–1903." *Journal of Material Culture* 10, no. 3 (2005): 263–87.

Miller, Barbara Stoler, trans. *The Bhagavad-Gita*. New York: Bantam Dell, 2004.

Mitter, Partha. *Art and Nationalism in Colonial India, 1850–1922: Occidental Orientations*. Cambridge and New York: Cambridge University Press, 1994.

Mitter, Partha. *Much Maligned Monsters: History of European Reactions to Indian Art*. Oxford: Clarendon Press, 1977.

Peck, Amelia, ed. *Interwoven Globe: The Worldwide Textile Trade, 1500–1800*. Exhibition catalogue. New York: Metropolitan Museum of Art, 2013.

Sherma, Rita DasGupta. "'Sa Ham—I Am She': Woman as Goddess." In *Is the Goddess a Feminist? The Politics of South Asian Goddesses*, edited by Alf Hiltebeitel and Kathleen M. Erndl, 24–51. New York: New York University Press, 2000.

Sikand, Yoginder. *Sacred Spaces: Exploring Traditions of Shared Faith in India*. New Delhi and New York: Penguin Books, 2003.

Sinha, Mrinalini. "A Global Perspective Gender: What's South Asia Got to Do with It?" In *South Asian Feminisms: Contemporary Interventions*, edited by Ania Loomba and Ritty A. Lukose, 356–73. Durham, N.C.: Duke University Press, 2012.

Tarar, Nadeem Omar. "From 'Primitive' Artisans to 'Modern' Craftsmen: Colonialism, Culture, and Art Education in the Late Nineteenth-Century Punjab." *South Asian Studies* 27, no. 2 (2011): 199–219.

Thapar, Romila. *Indian Society and the Secular*. Gurgaon, Haryana, India: Three Essays Collective, 2016.

Williams, Joanna. *Kingdom of the Sun: Indian Court and Village Art from the Princely State of Mewar*. Exhibition catalogue. San Francisco: Asian Art Museum, 2007.

Index